YORKSHIRE IN PHOTOGRAPHS

First published 2016

Amberley Publishing
The Hill, Stroud
Gloucestershire, GL5 4EP

www.amberley-books.com

Copyright © Dave Zdanowicz, Dave Z Photography, 2016

The right of Dave Zdanowicz to be identified as the Author of this work has been asserted in accordance with the Copyrights, Designs and Patents Act 1988.

ISBN 978 1 4456 5395 2 (print)
ISBN 978 1 4456 5396 9 (ebook)

British Library Cataloguing in Publication Data.
A catalogue record for this book is available from the British Library.

Typesetting by Amberley Publishing.
Printed in the UK.

YORKSHIRE IN PHOTOGRAPHS

DAVE ZDANOWICZ

AMBERLEY

ACKNOWLEDGEMENTS

I would like to thank my dad, Paul, for inspiring me to become a better photographer. Thanks for all the lifts to the destinations. Without you there, would be no pictures for this book! And my mother, Pauline, for being a wonderful mum. Thanks to my girlfriend, Treacy, and my son, Jack, for letting me go out so much to take the photographs for this book. And thanks go to my amazing family and friends for your support. Thank you to Kenko Tokina and Hoya for making me a proud ambassador of their company, and to Imran Mirza from Photography by Imran for giving me the idea and confidence to approach a publisher about creating my own book.

I would also like to thank the following people and organisations:

Canon UK & Ireland; Tamron; Jane Nicholson; Intro 2020; Keeley Donovan and Paul Hudson from BBC Weather for always supporting my photography; Karen Shaw and Alex Cowland from *Northern Life* magazine for giving my work some amazing publicity; Dean Murray, Sophie Exton, Carmela Rodriguez and Adam Bennett for giving me the chance to share my work with the world; Welcome to Yorkshire for showcasing my work; Derek Momodu from the *Daily Mirror*; Elliot Wagland from the *Huffington Post*; Oddny Edwards at *Vanguard*; Emma Clayton and the *Bradford Telegraph & Argus* for showcasing my work; Martin Shaw/Samantha Robinson and the *Huddersfield Examiner*; Chris Lever and the *Halifax Courier*; BBC Radio Leeds; Lewis Peel for making my amazing website, you are truly a genius;

Brahim Abdellaoui for selling me my first camera and getting me interested in photography, I owe you big time; Alan Murphy at Amberley for giving me the chance to make my own book; *BBC Countryfile Magazine*; *On Magazine*; Michelle at Seeing Rainbows; Holiday at Home (holidayathome. co.uk); *Yorkshire Living*; Adrian Braddy at *Dalesman Magazine*; *EOS Magazine*; the Strictly Yorkshire photography group on Facebook. I am inspired by the wonderful photographers who post on there.

A huge thanks to all my followers on Facebook, Twitter and Instagram. You have created so many great opportunities for me. I really appreciate you all taking the time to view my photography.

Finally, thanks to all the photographers who have inspired me:

Paul Zdanowicz Photography, www.facebook.com/pzdanphotography
Zi Photography, www.ziphotography.co.uk
Michiko Smith, www.facebook.com/michikosmithphotography
Dean Matthews Photography, www.facebook.com/dean.matthews.photography
Daryll Davies, www.darylldavies.co.uk
Photography By Imran, www.photographybyimran.com
Matty White Photography, www.facebook.com/MattyWhitePhotography/
Dave & Bev Cappleman
Holly Bailey Photography, www.facebook/hollybphotography

ABOUT THE PHOTOGRAPHER

Born and raised in Bradford, West Yorkshire, Dave Zdanowicz is a landscape photographer who is very proud of his home town. He purchased his first camera in 2013 and has not looked back since.

As his gallery continues to grow, so have the requests from people to purchase a book of his work. The main inspiration for this book has been his online following, which has now grown to over 100,000 followers cross platform.

Dave has achieved a lot so far in his photography career. He has provided images for a number of books, as well as images to major TV networks including BBC, ITV and Sky, and his pictures have regularly been published nationally and internationally in newspapers and magazines. He has also won many major UK landscape competitions, including the BBC Countryfile competition. Leading camera companies such as Canon and Tamron have also featured his work.

He uses a Canon 6D with a range of lenses included Tokina 16-28, Canon 17-40L series, Tamron 24-70 and Tamron 70-200, a range of HOYA filters and a range of Vanguard tripods and bags.

Website: www.davezphotography.co.uk
Facebook: www.facebook.com/davezphoto
Twitter: @davez_uk
Instagram: @davez_uk
Email: info@davezphotography.co.uk

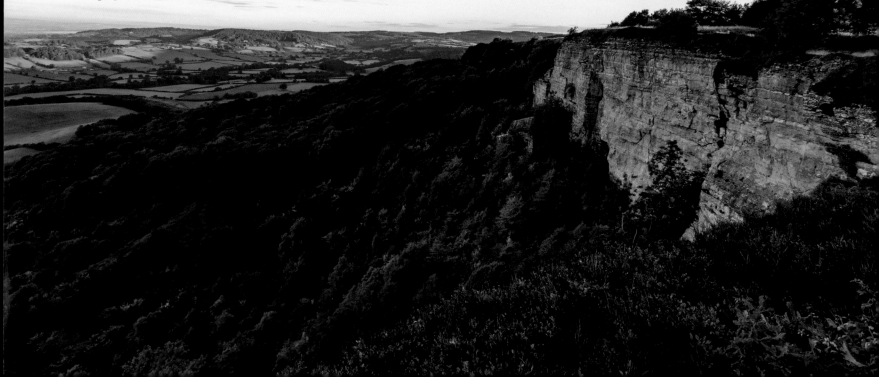

INTRODUCTION

I first became interested in photography in 2013 when my good friend Brahim was selling his old camera. He offered me a great price and I'm a sucker for a bargain so I bought it without hesitation. Ever since then I have become passionate about photography and even more so about capturing the magic of Yorkshire's landscapes.

Every spare moment I have is dedicated to visiting various locations around the county with my dad, Paul, who is a fantastic photographer. Photography has given us a great excuse to go out and see what amazing sights Yorkshire has to offer; many of which I would have never have known about if not for exploring with my camera.

The images in this book have been selected from my collection over the last couple of years. In the course of taking these photographs I have explored moors and hills, reservoirs and lakes, beaches and cliffs, towns, villages and cities and each picture represents a unique moment in time, captured at a particular time of the year.

SPRING

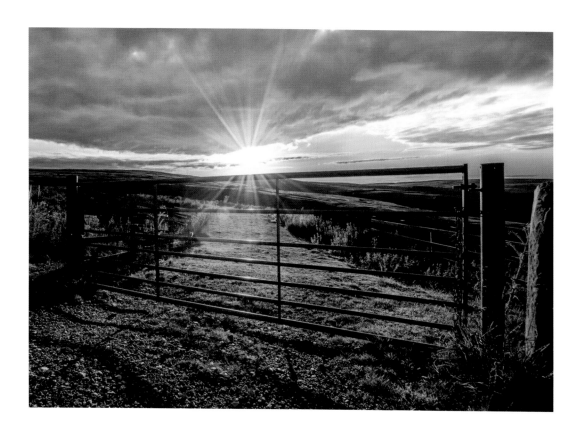

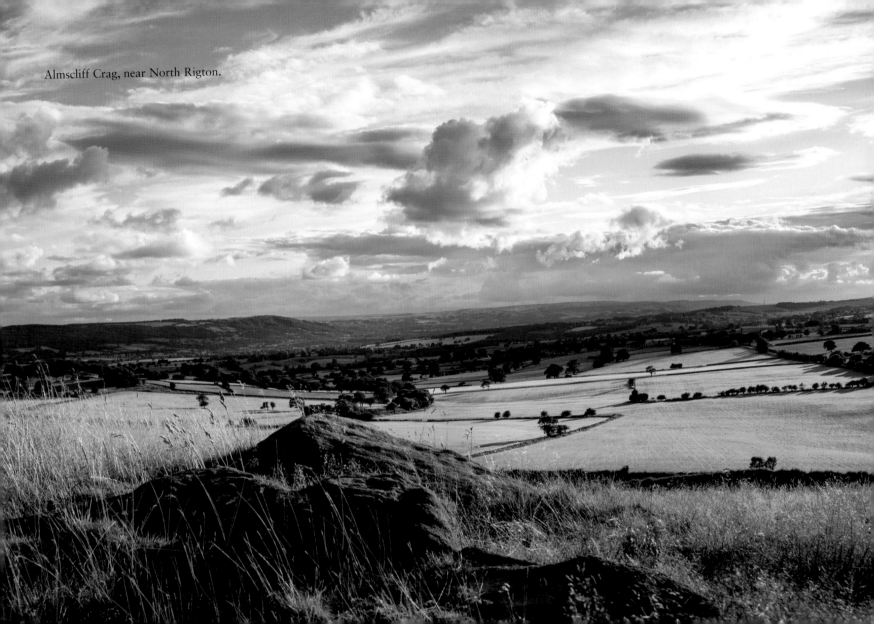

Almscliff Crag, near North Rigton.

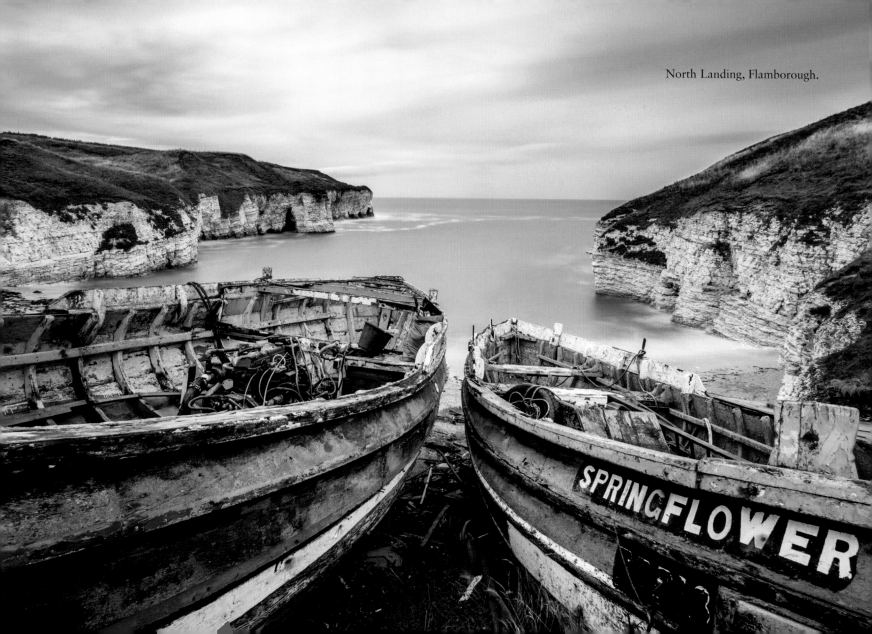

North Landing, Flamborough.

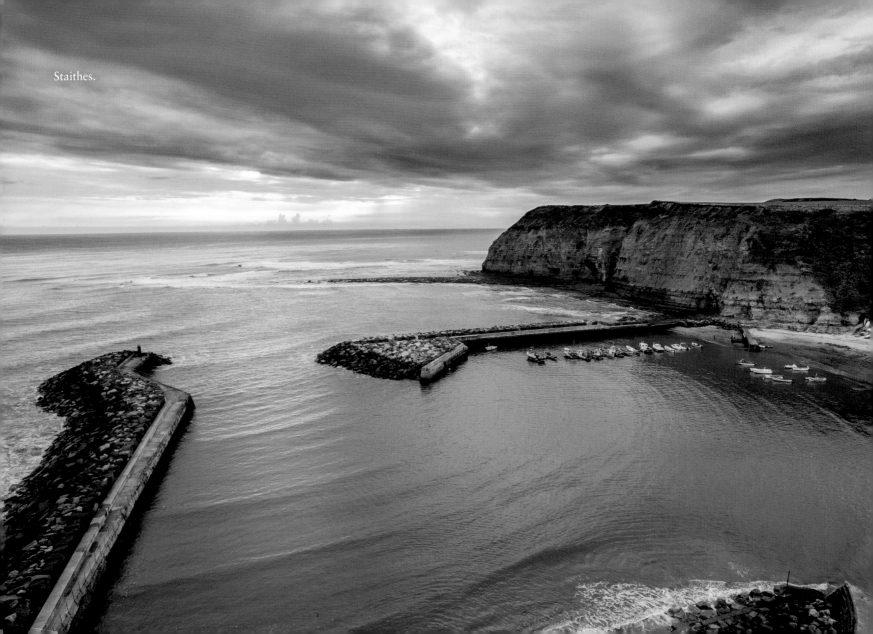
Staithes.

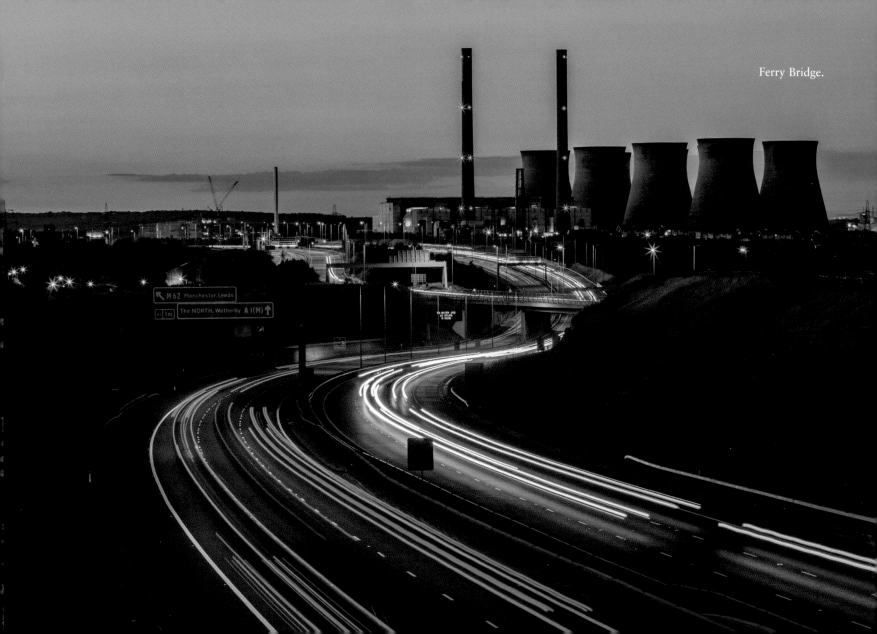

Ferry Bridge.

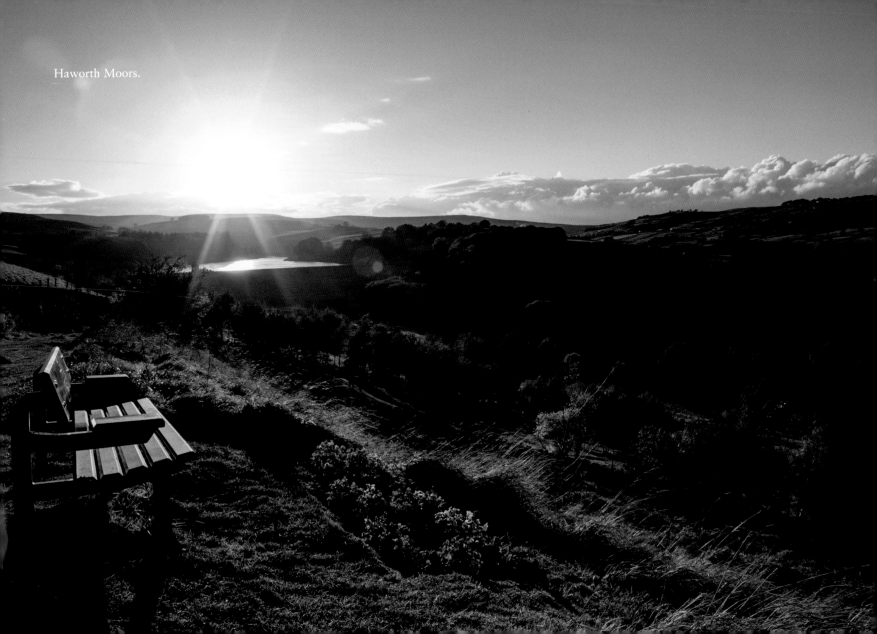

Haworth Moors.

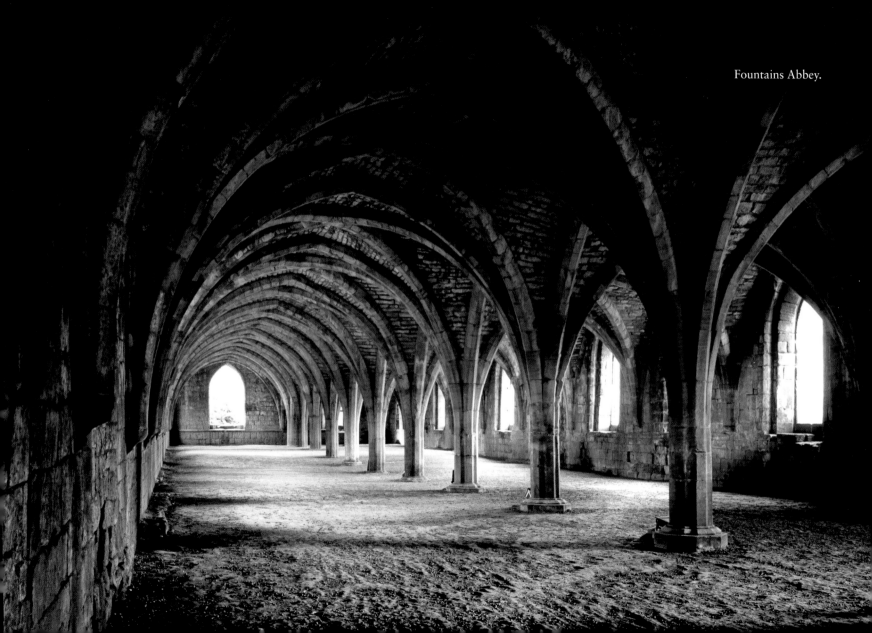

Fountains Abbey.

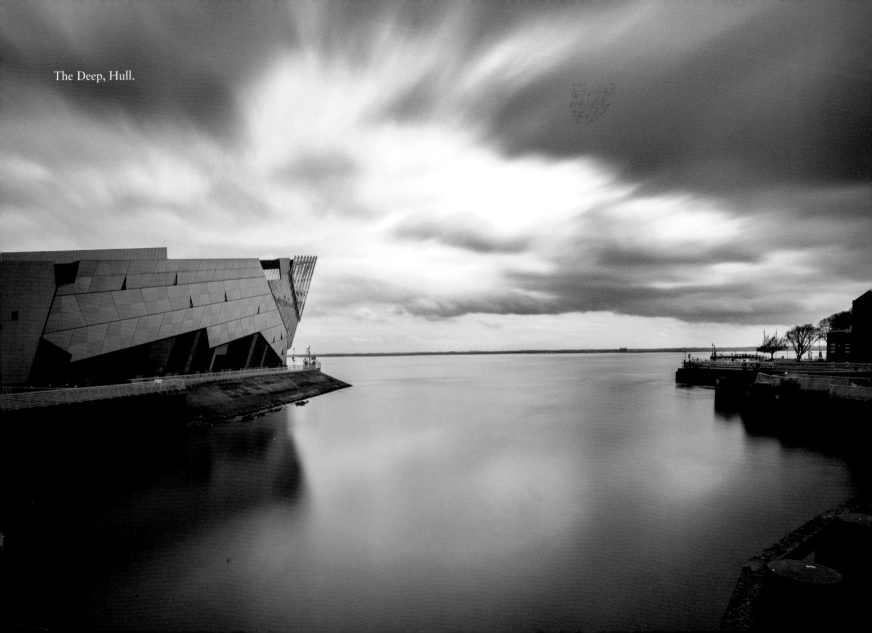

The Deep, Hull.

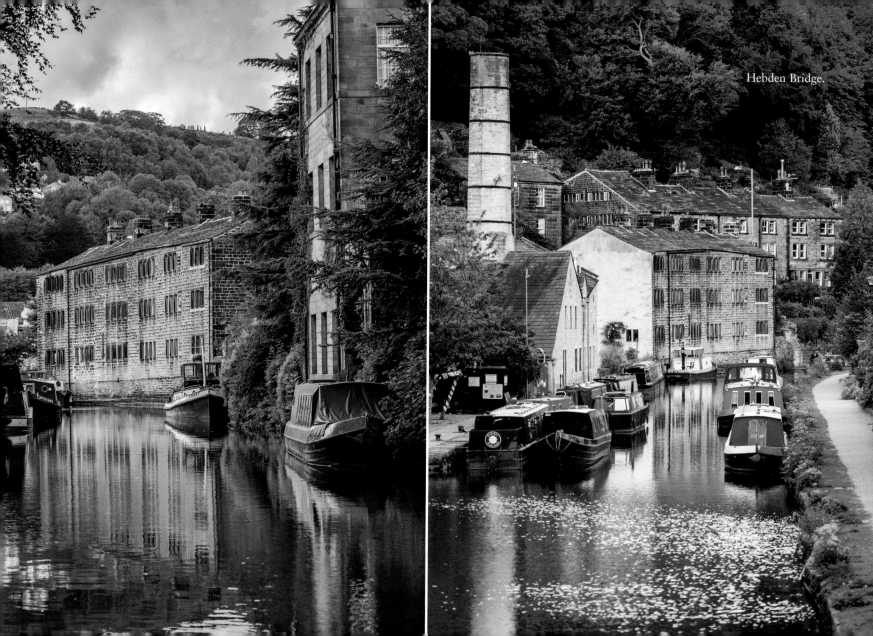

Hebden Bridge.

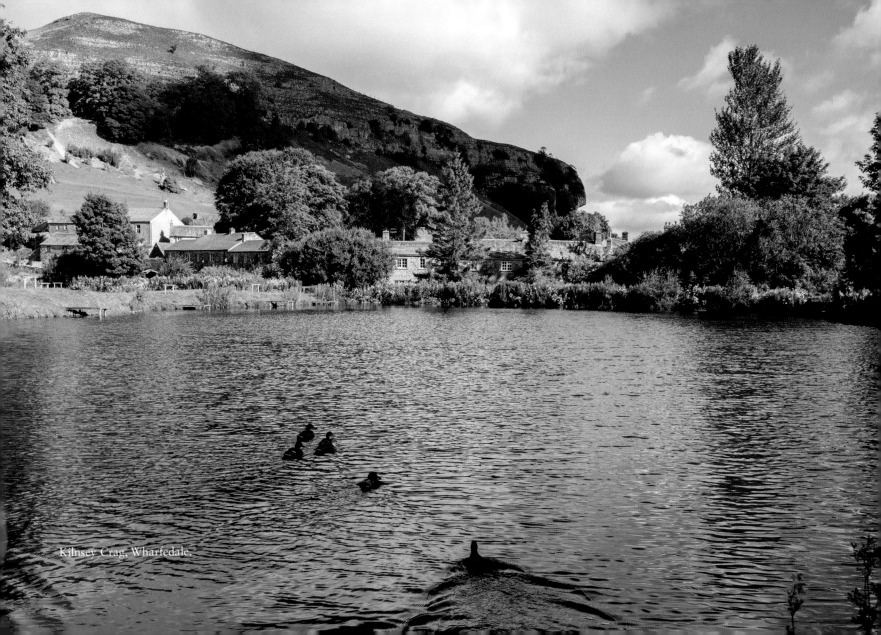

Kilnsey Crag, Wharfedale.

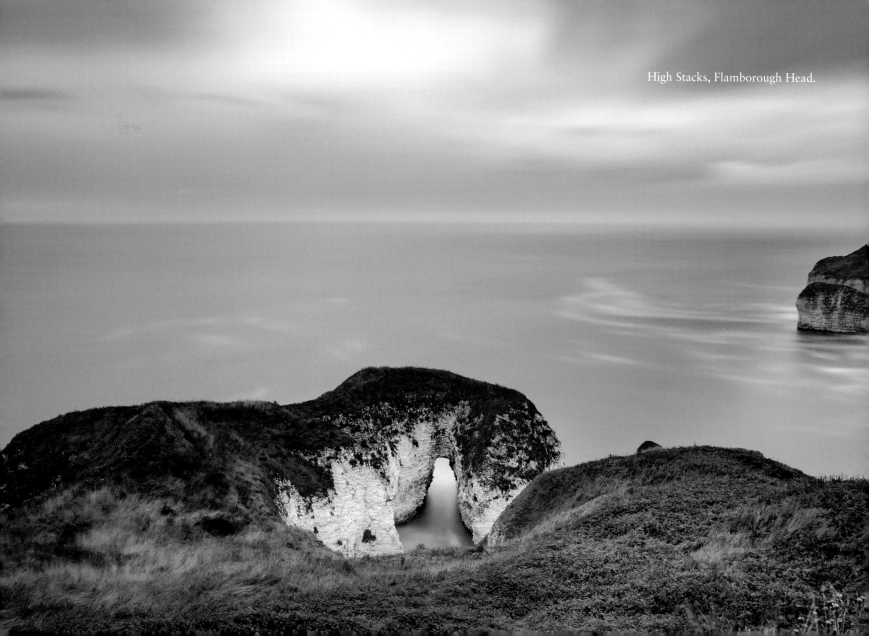

High Stacks, Flamborough Head.

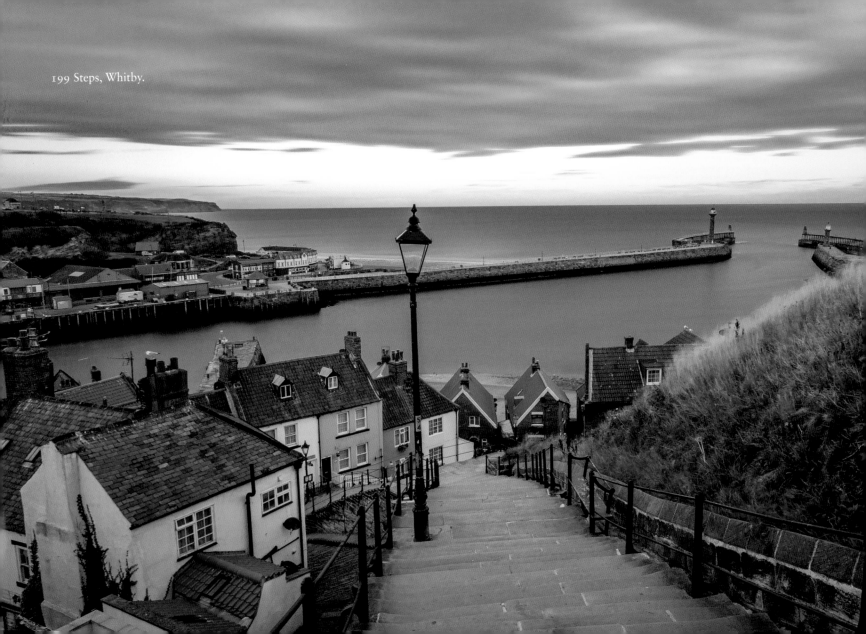

199 Steps, Whitby.

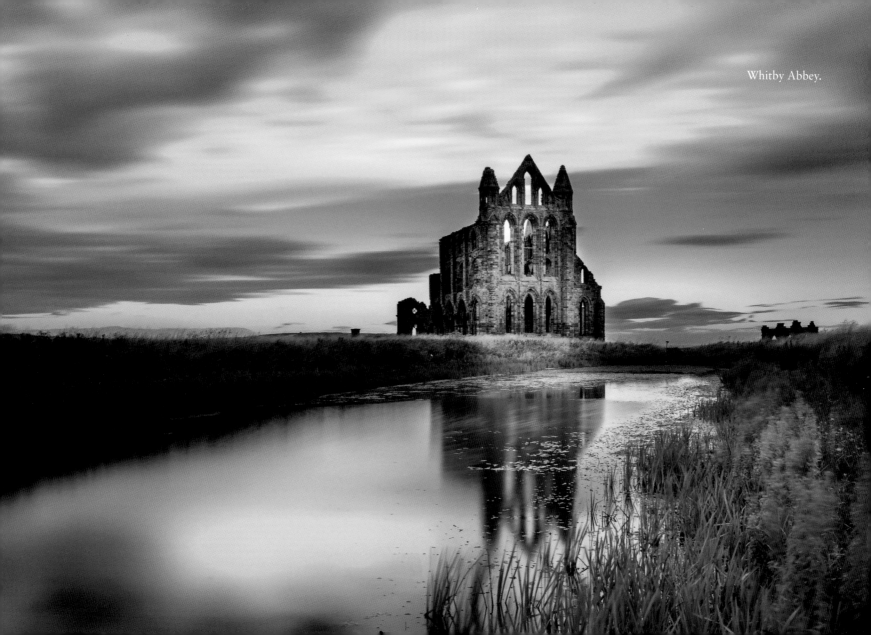
Whitby Abbey.

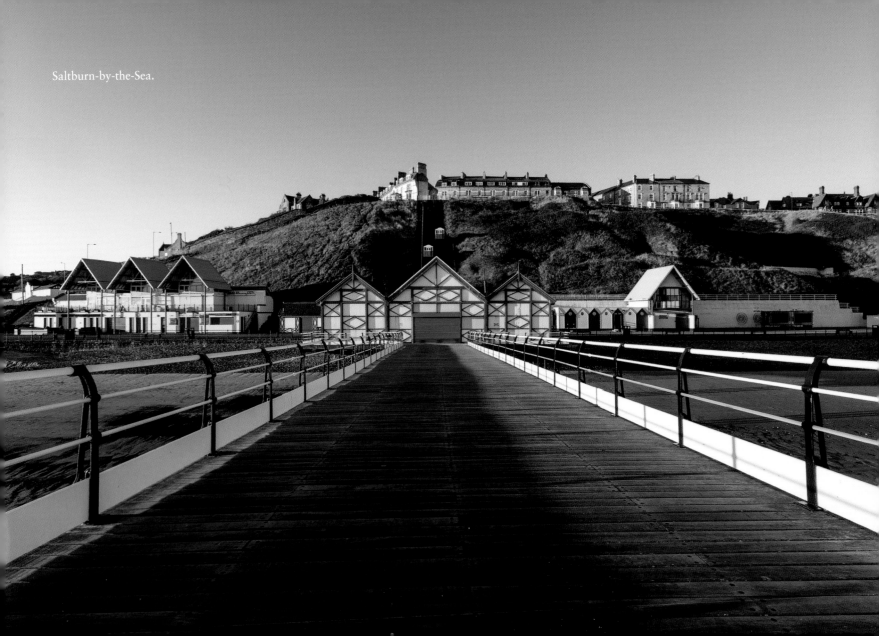

Saltburn-by-the-Sea.

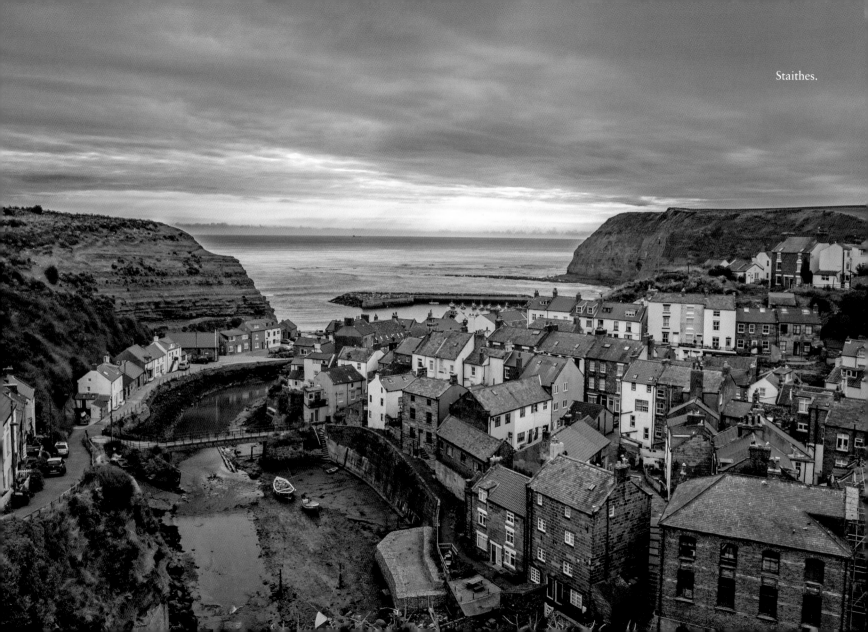

Staithes.

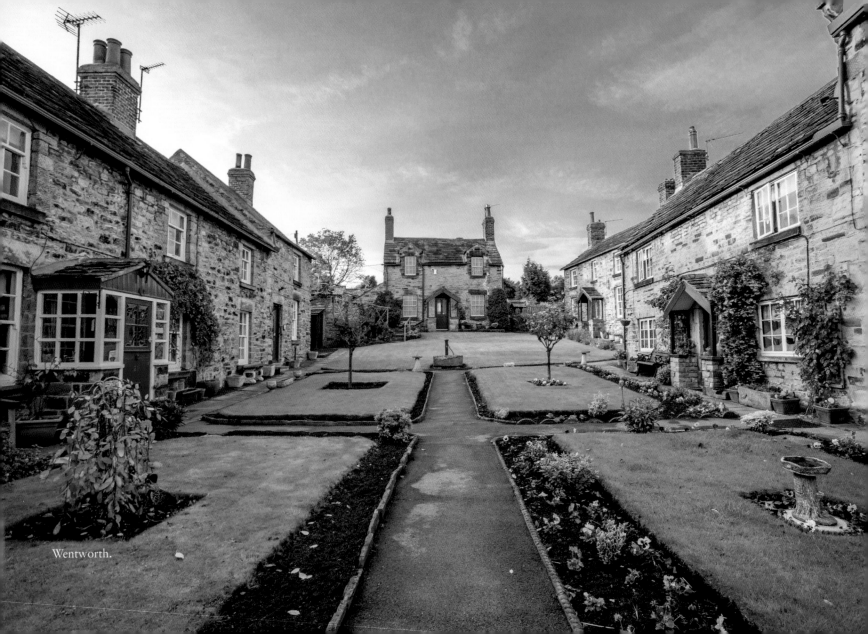

Wentworth.

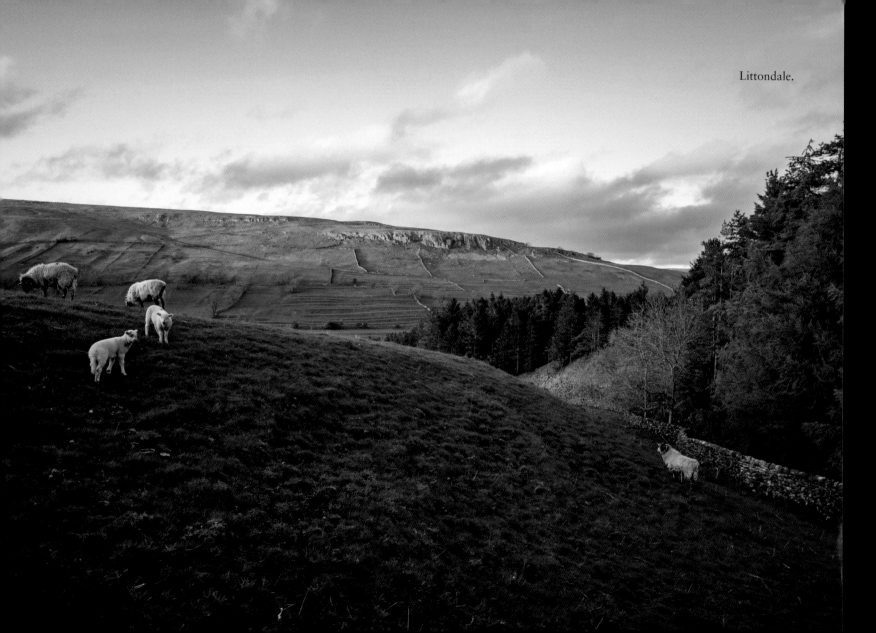

Littondale.

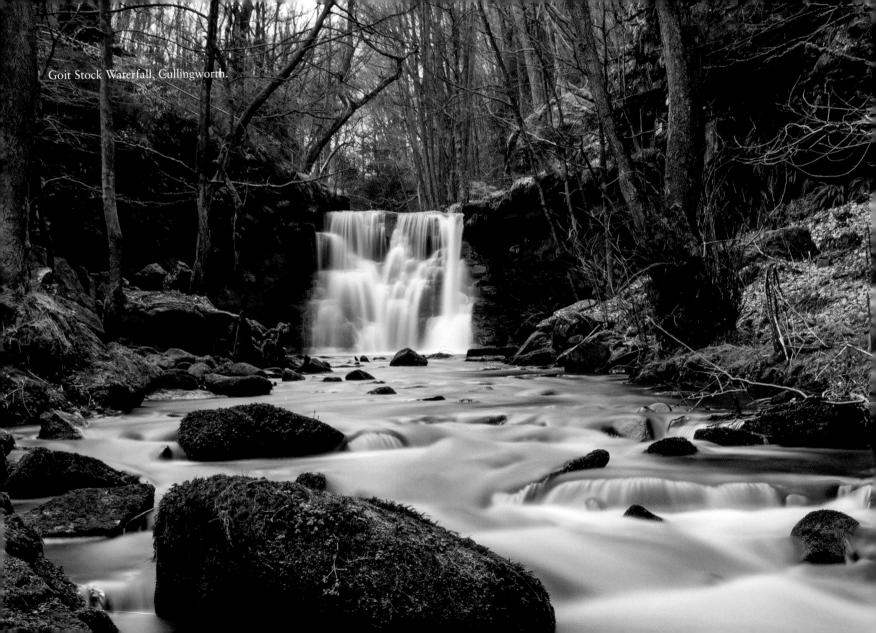
Goit Stock Waterfall, Cullingworth.

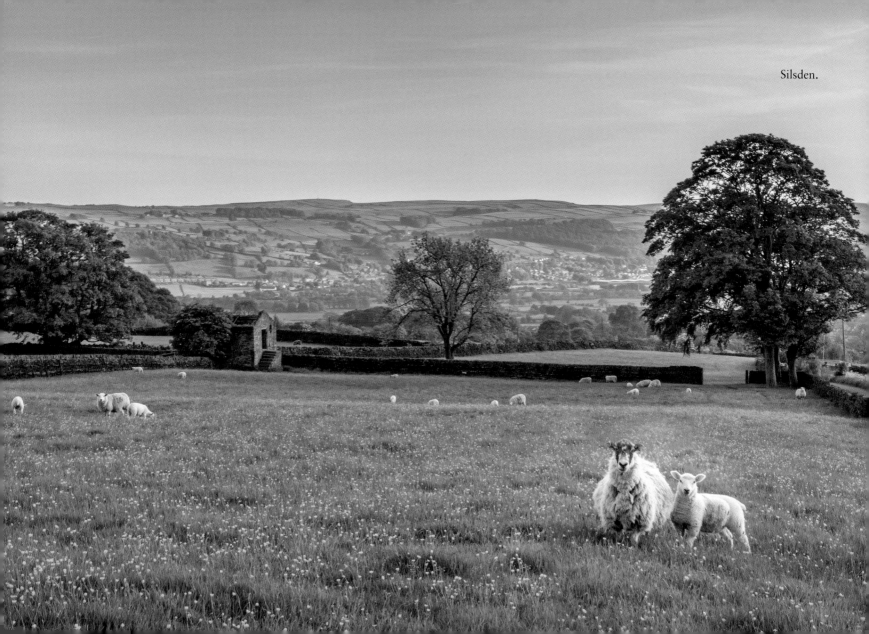

Silsden.

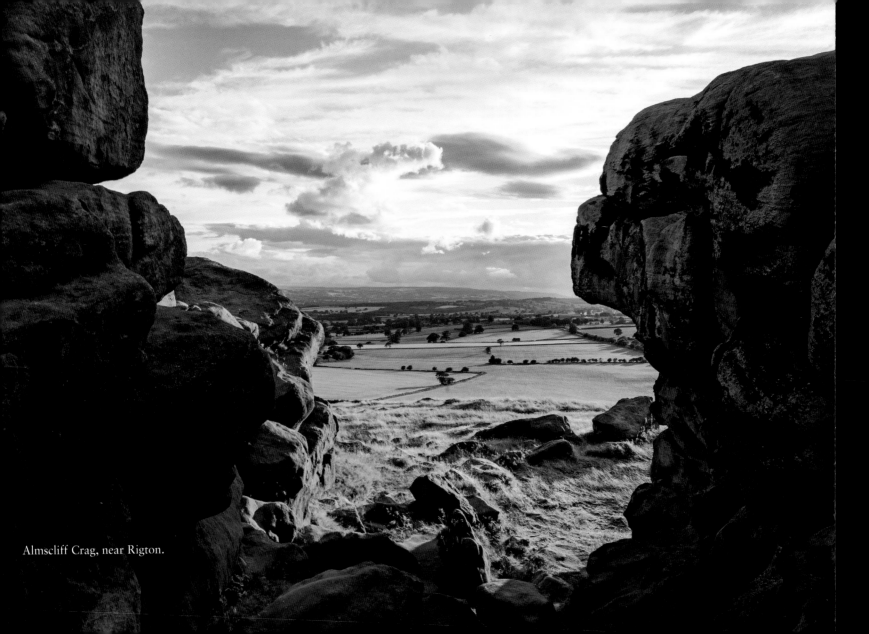

Almscliff Crag, near Rigton.

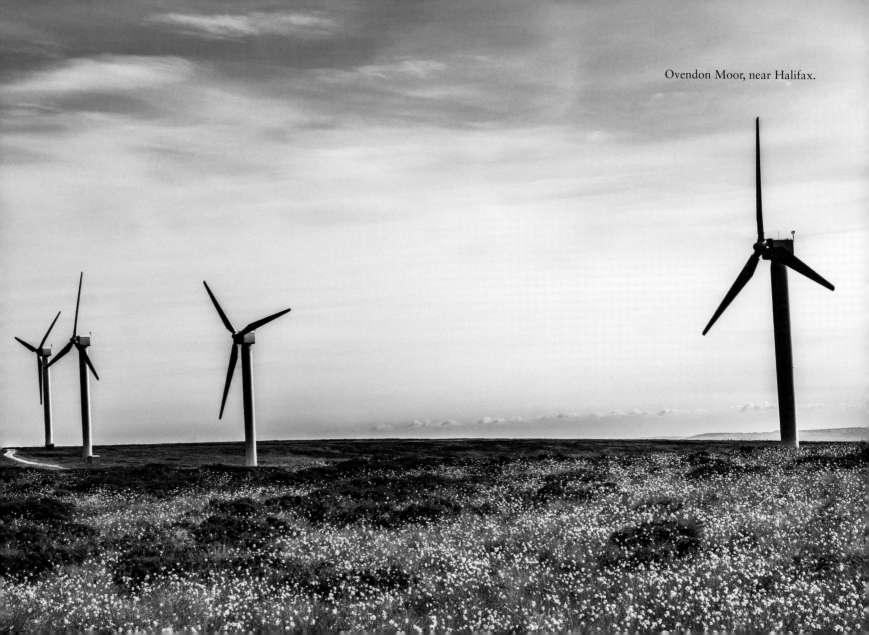

Ovendon Moor, near Halifax.

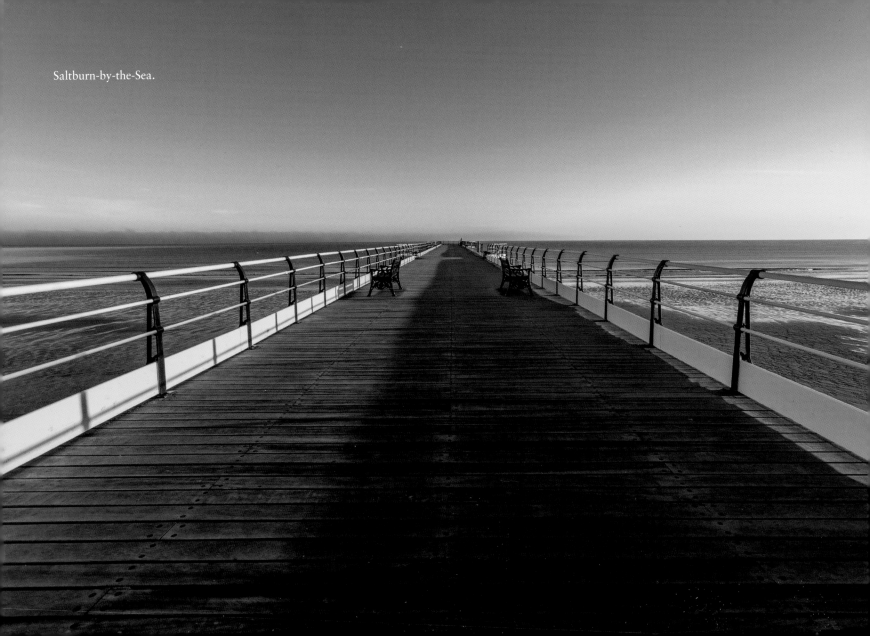

Saltburn-by-the-Sea.

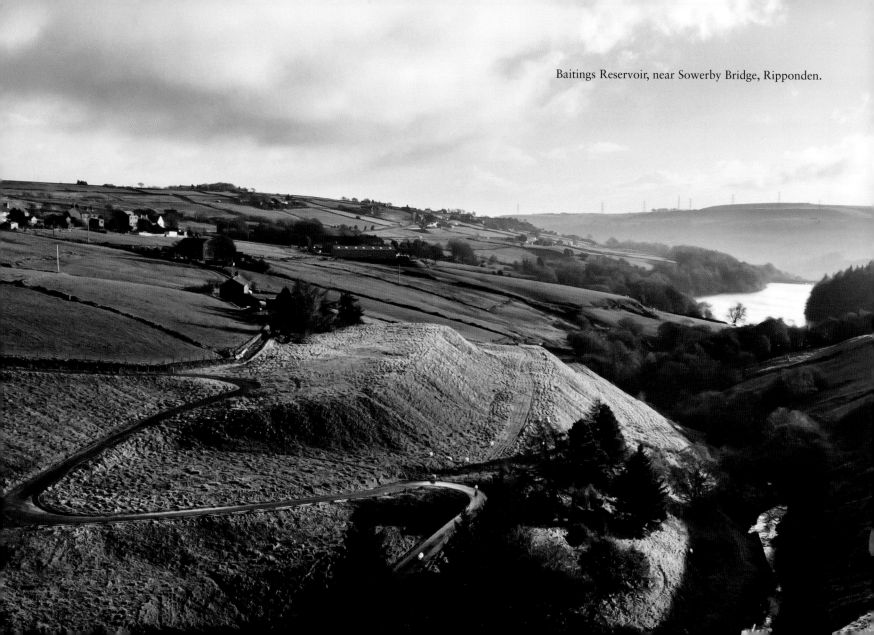

Baitings Reservoir, near Sowerby Bridge, Ripponden.

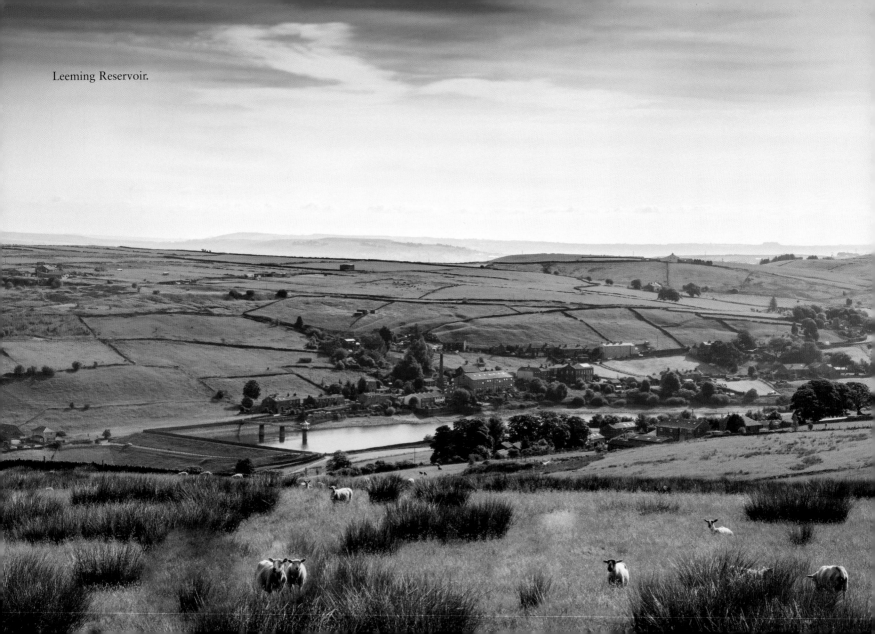

Leeming Reservoir.

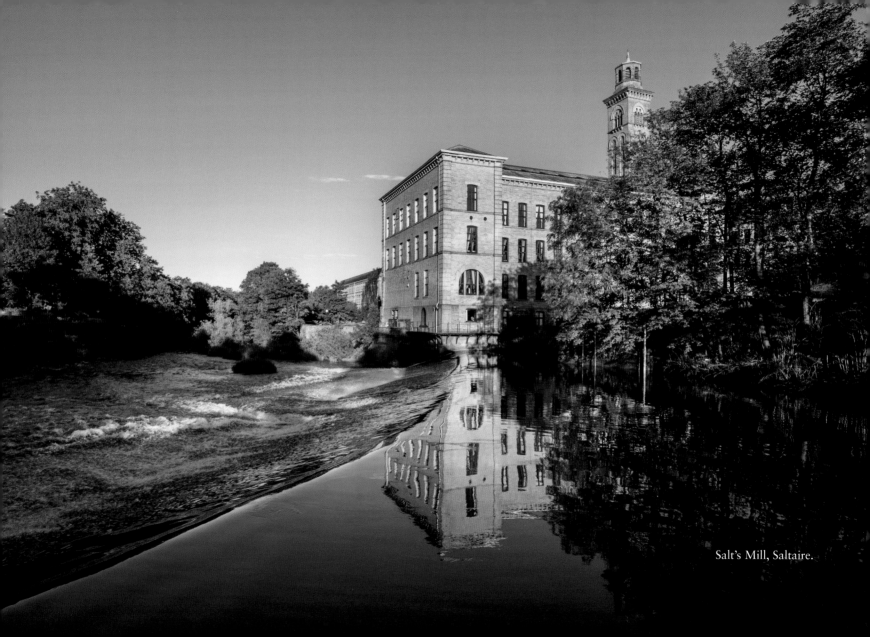

Salt's Mill, Saltaire.

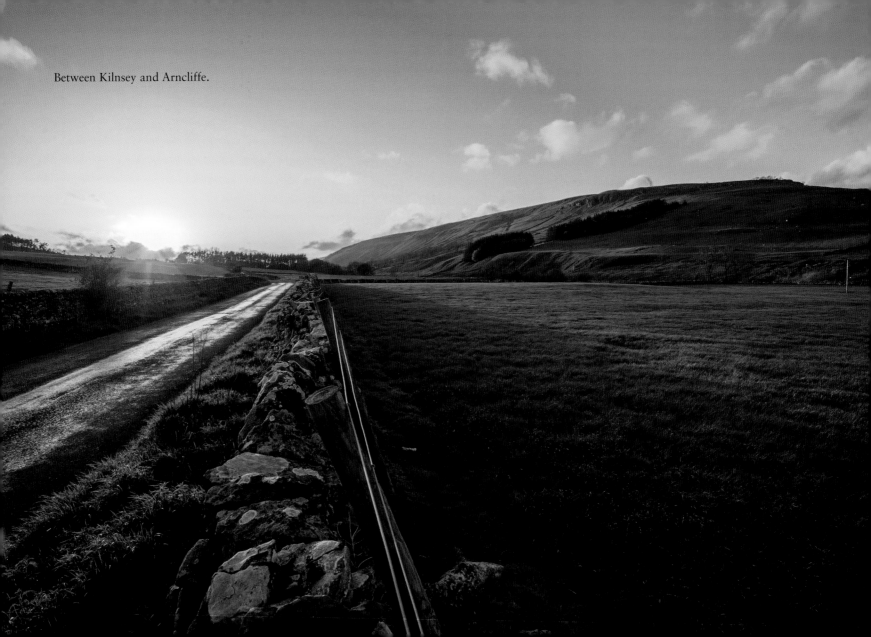

Between Kilnsey and Arncliffe.

SUMMER

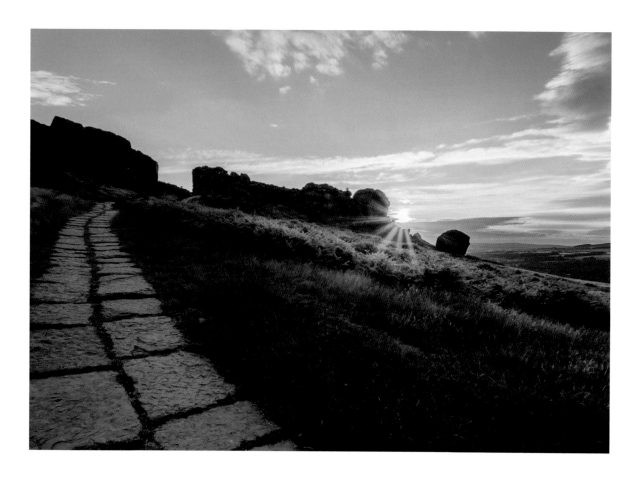

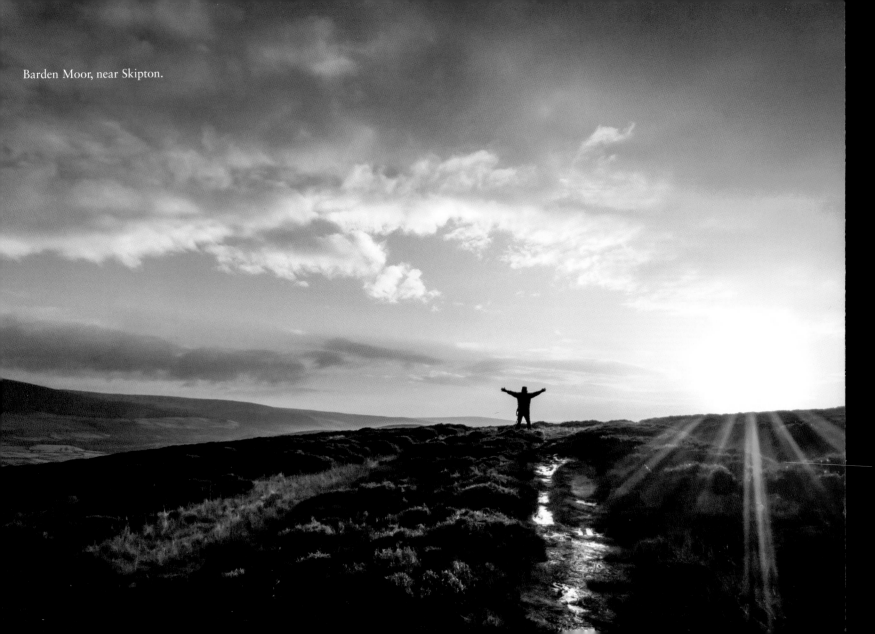

Barden Moor, near Skipton.

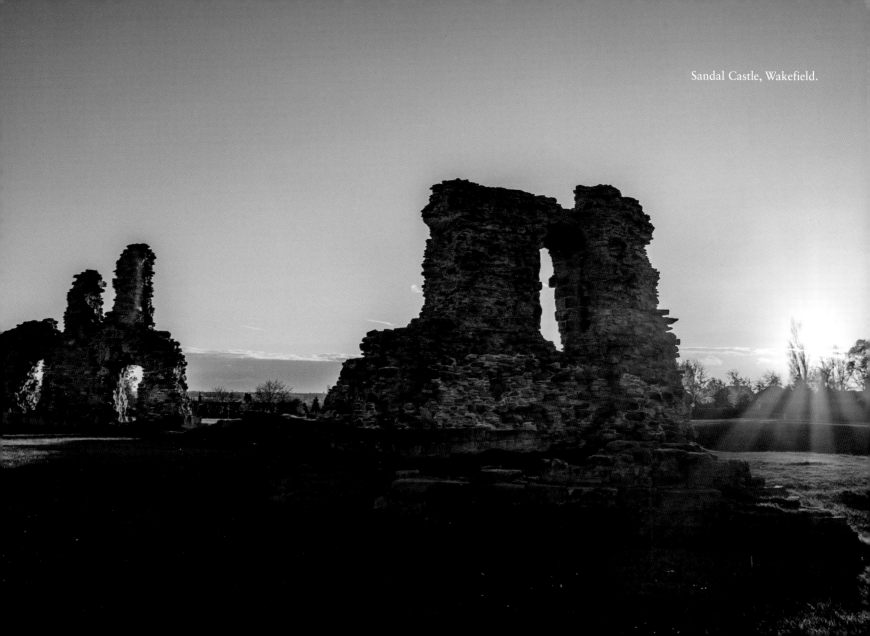

Sandal Castle, Wakefield.

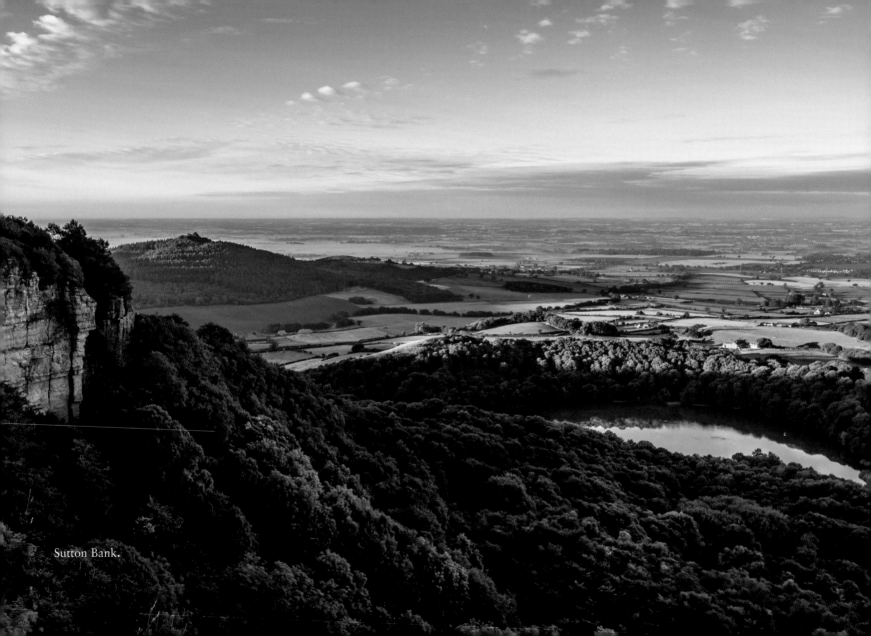

Sutton Bank.

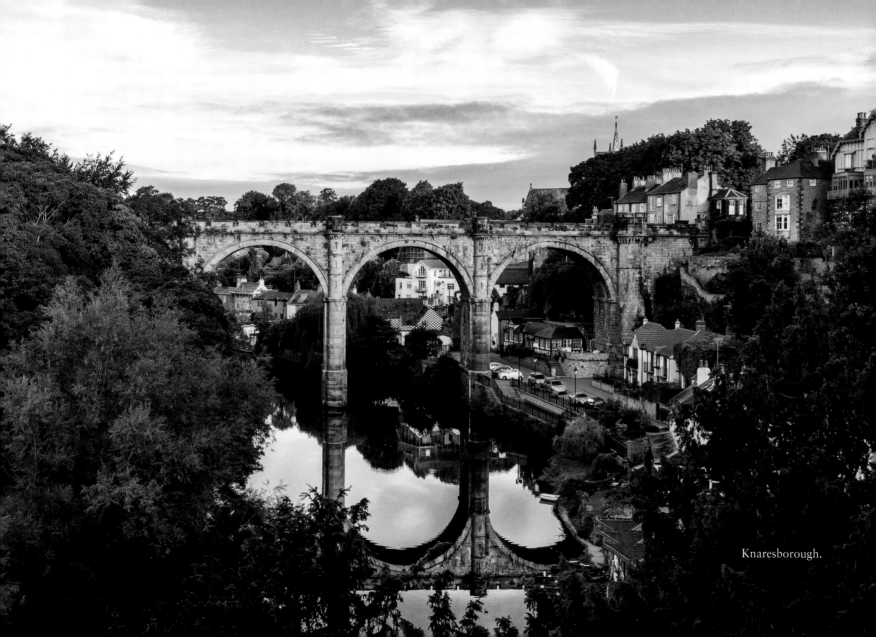

Knaresborough.

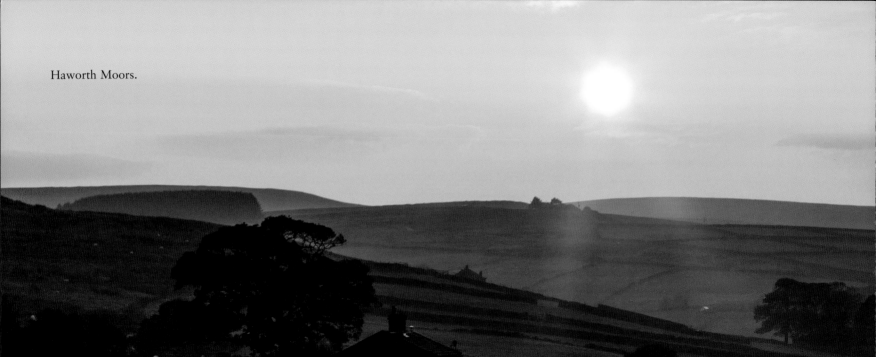

Haworth Moors.

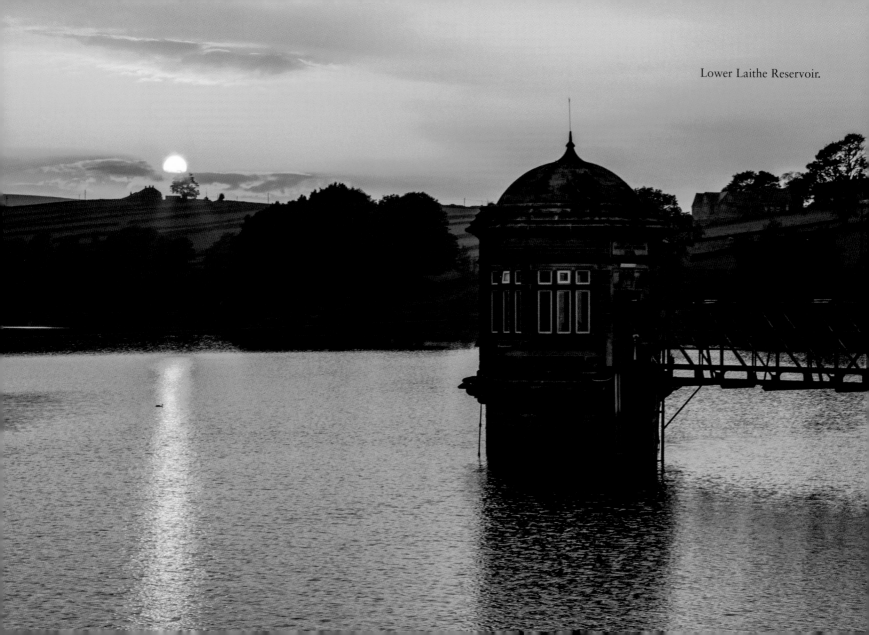

Lower Laithe Reservoir.

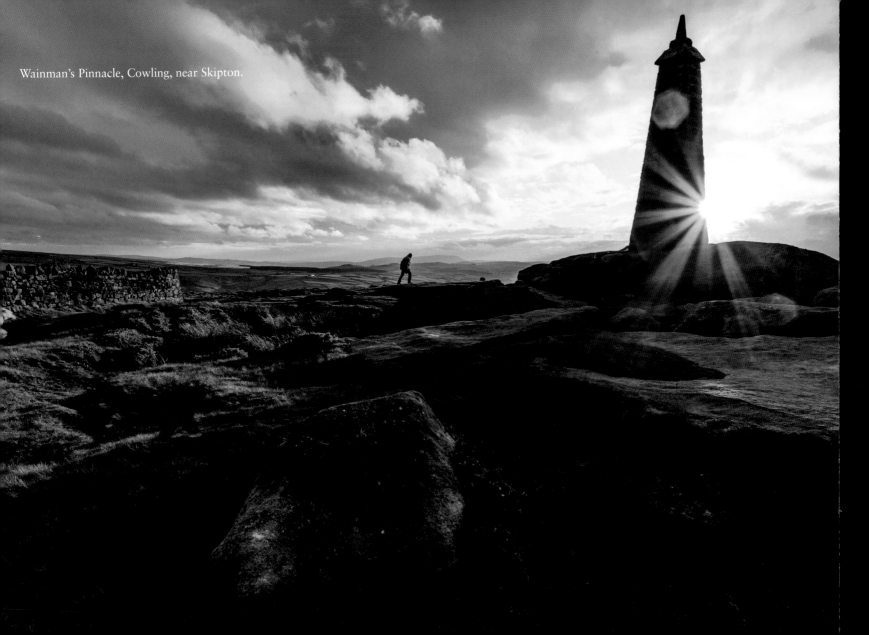

Wainman's Pinnacle, Cowling, near Skipton.

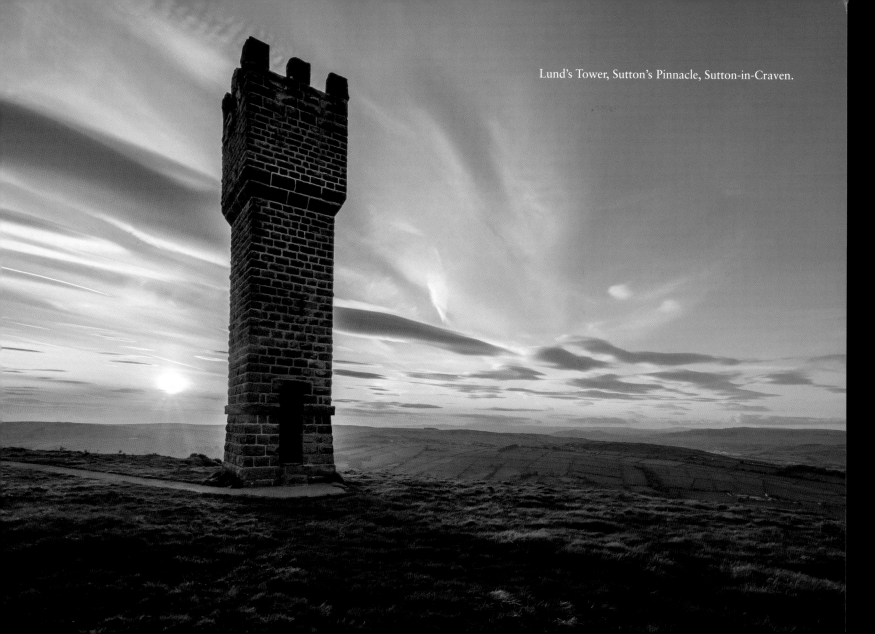

Lund's Tower, Sutton's Pinnacle, Sutton-in-Craven.

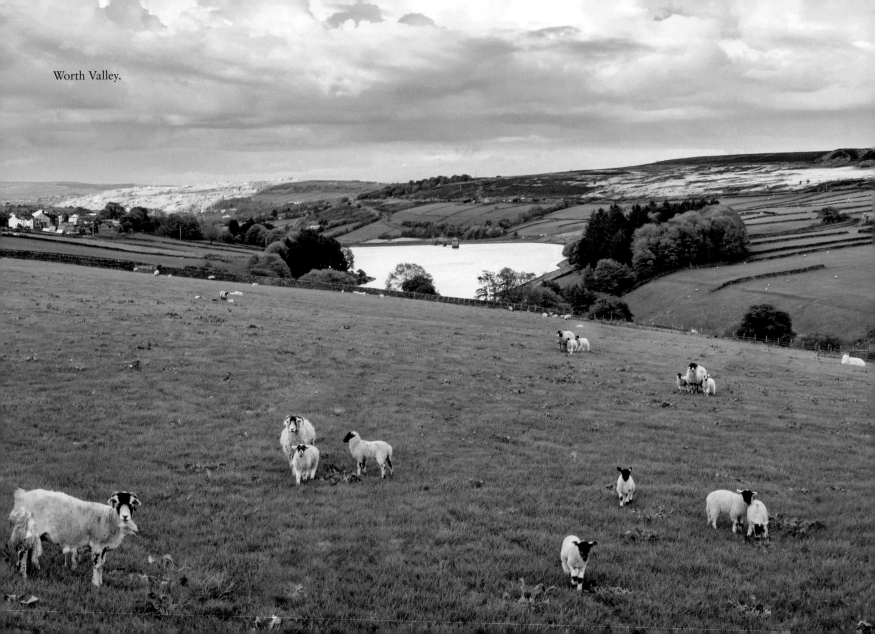

Worth Valley.

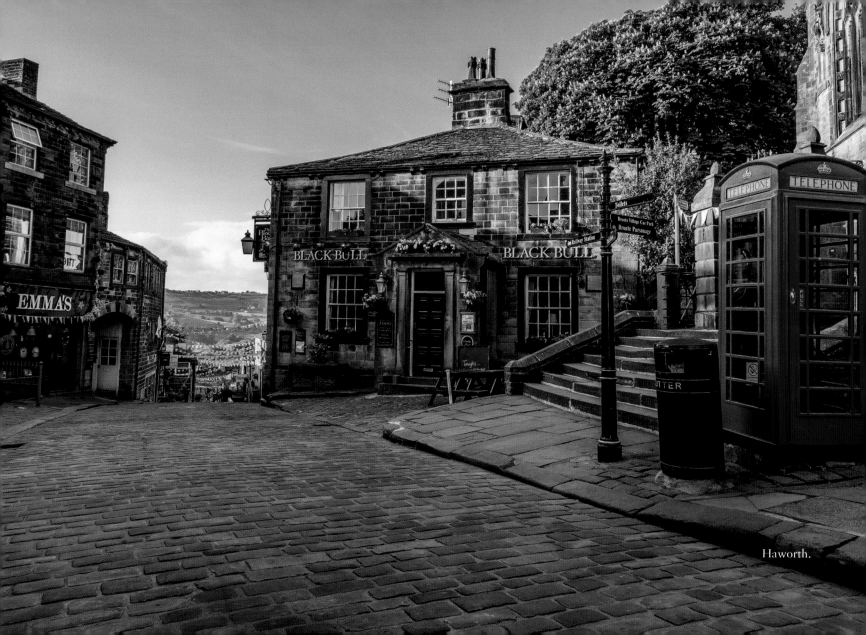

Haworth.

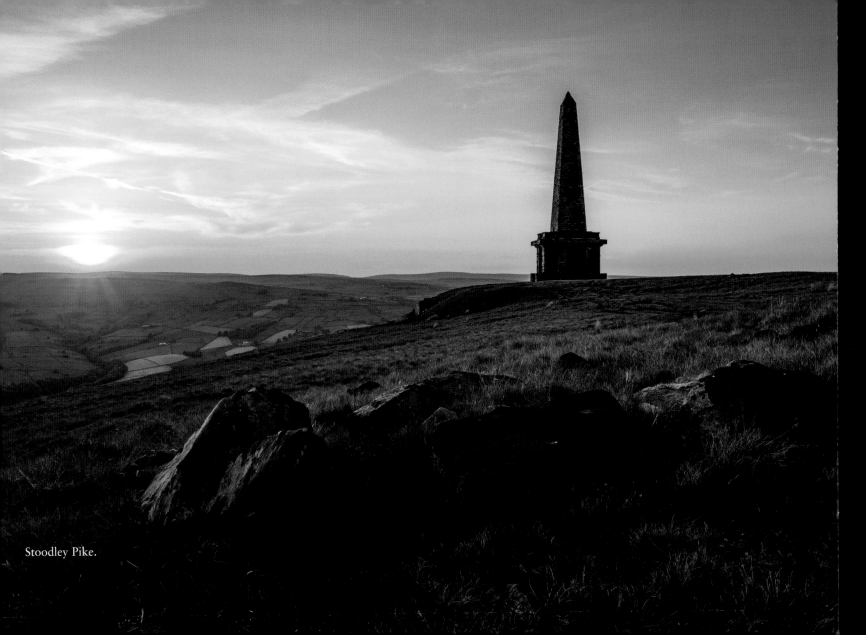

Stoodley Pike.

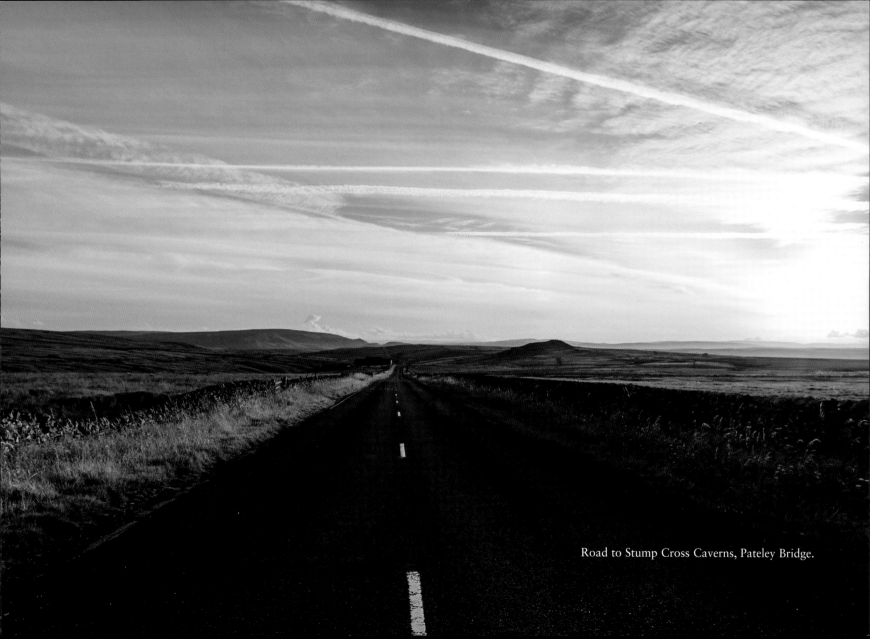

Road to Stump Cross Caverns, Pateley Bridge.

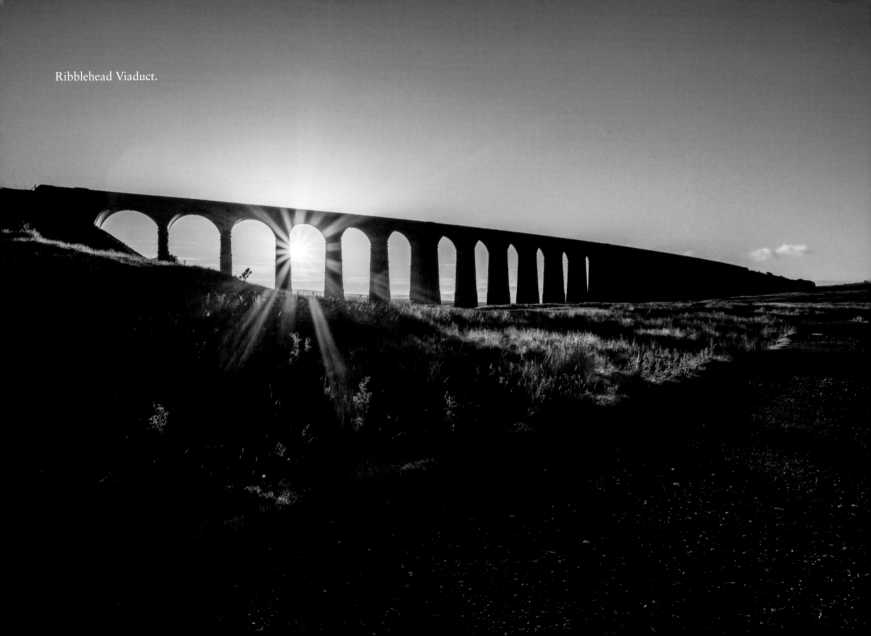

Ribblehead Viaduct.

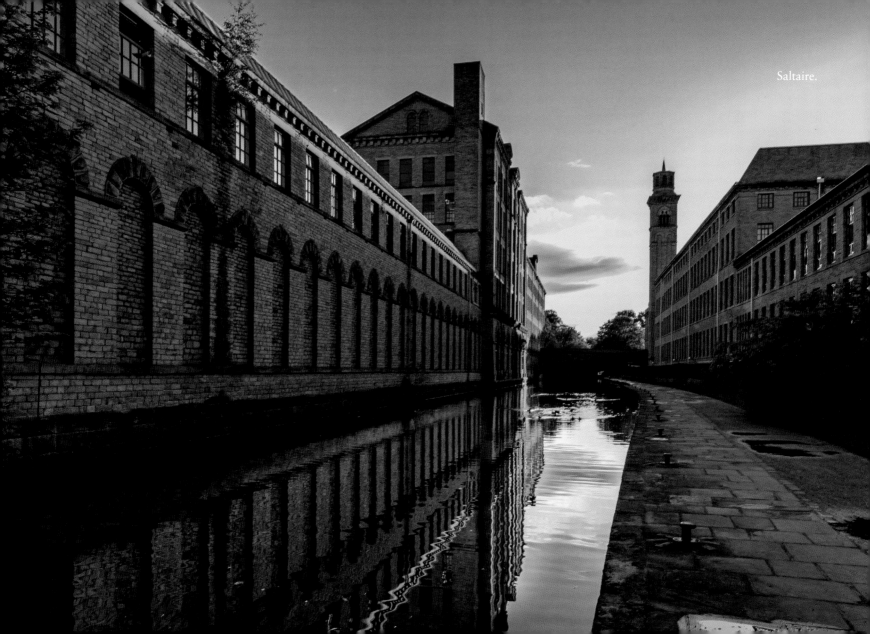

Saltaire.

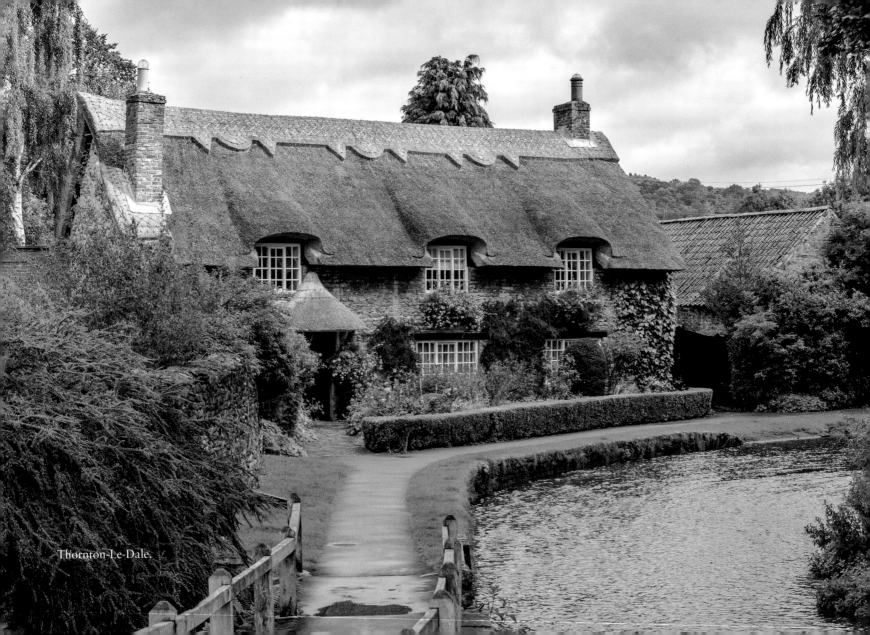

Thornton-Le-Dale.

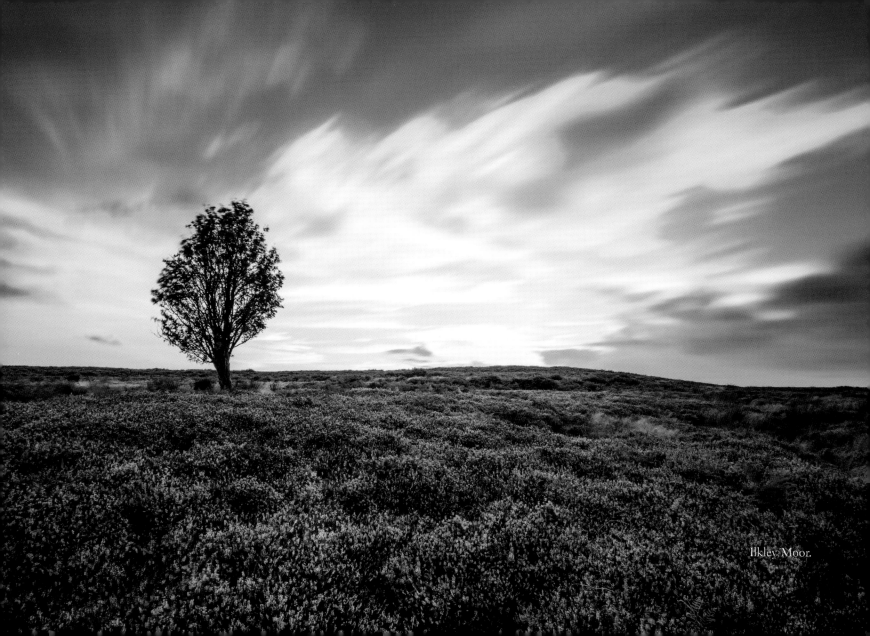

Ilkley Moor.

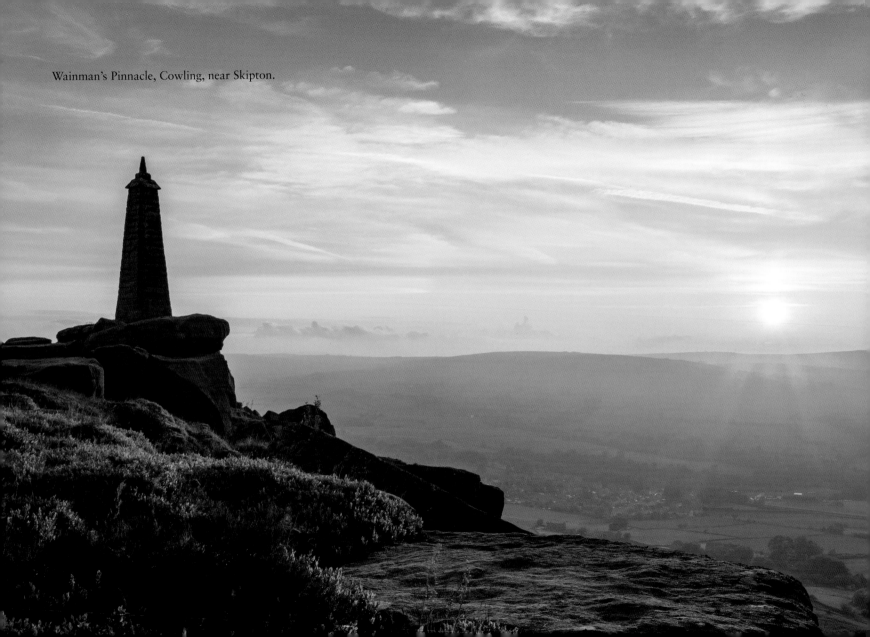

Wainman's Pinnacle, Cowling, near Skipton.

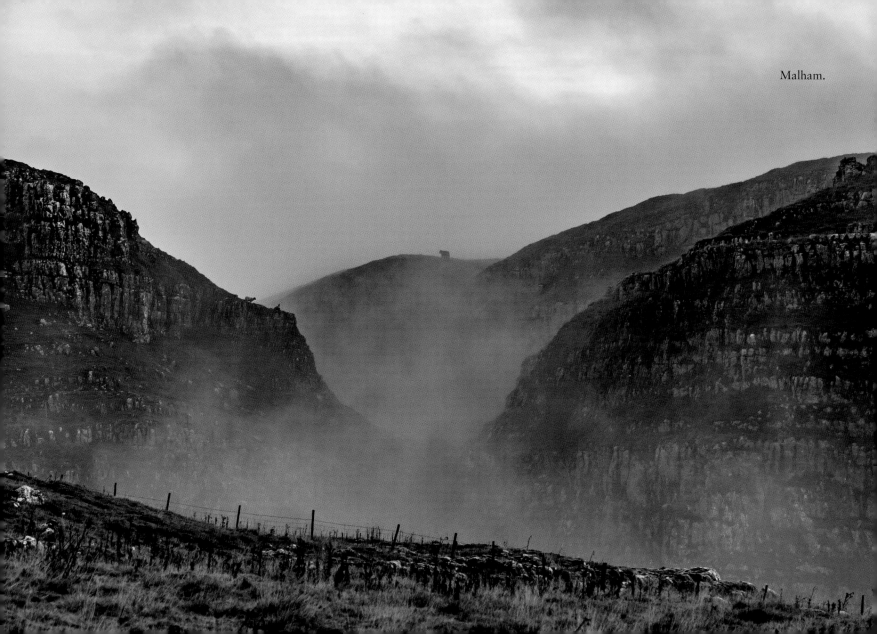

Malham.

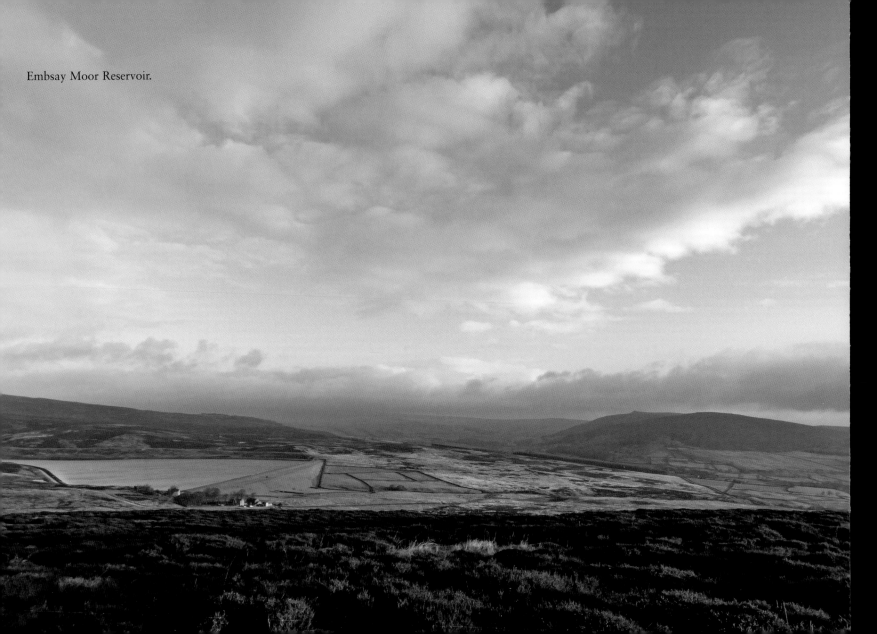

Embsay Moor Reservoir.

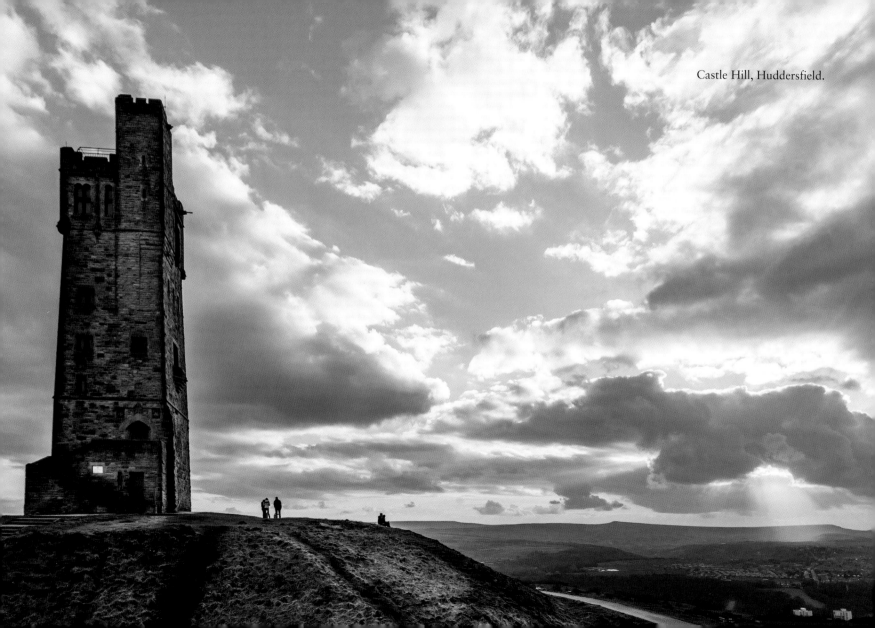

Castle Hill, Huddersfield.

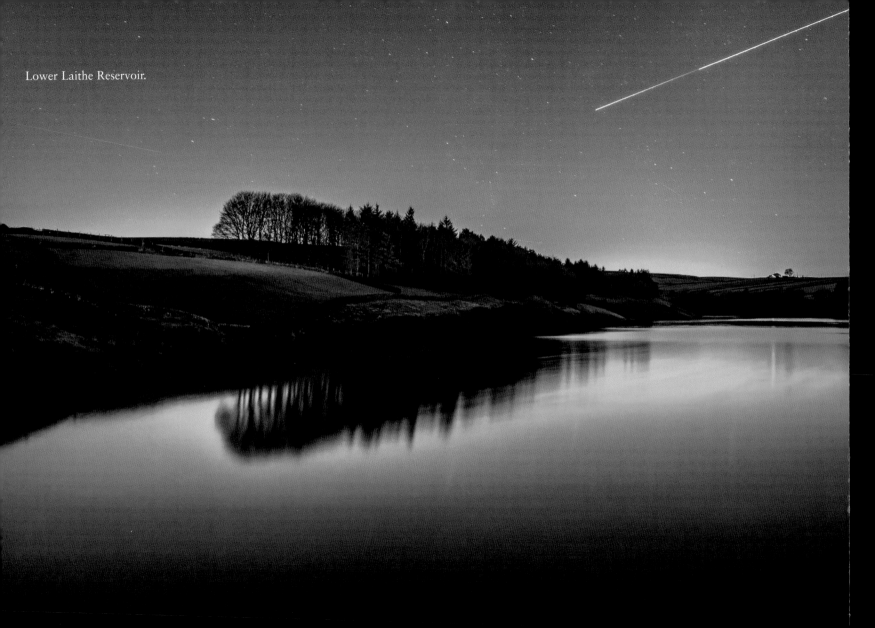

Lower Laithe Reservoir.

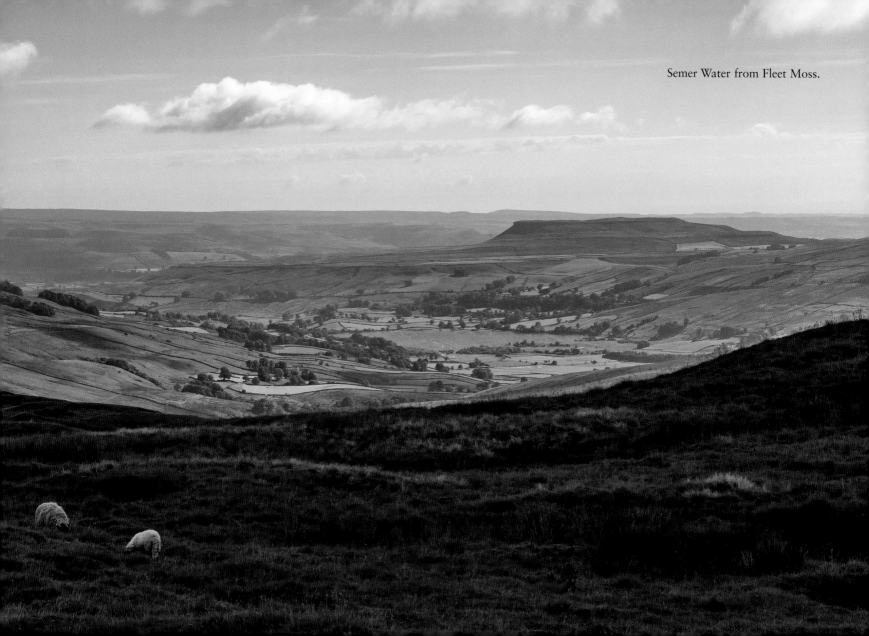

Semer Water from Fleet Moss.

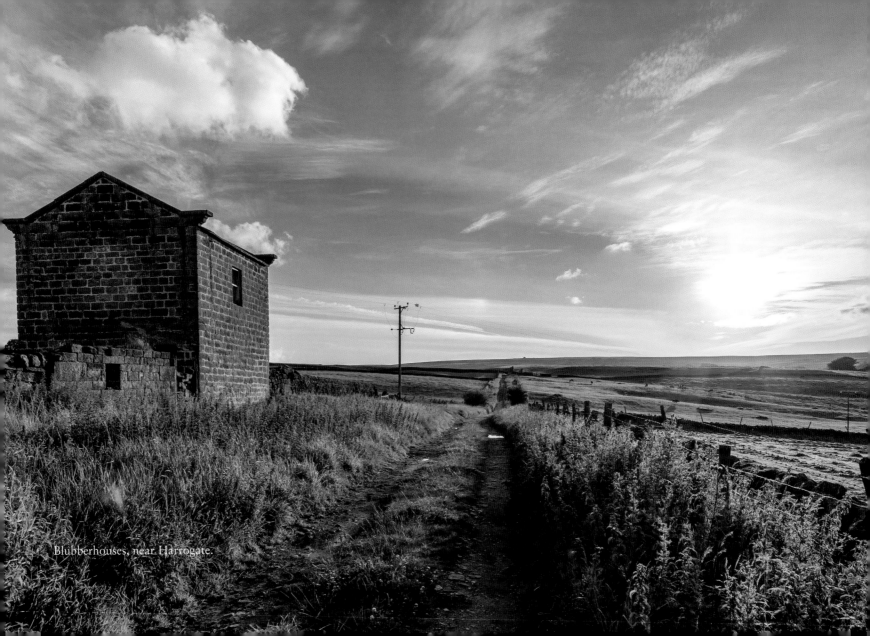

Blubberhouses, near Harrogate.

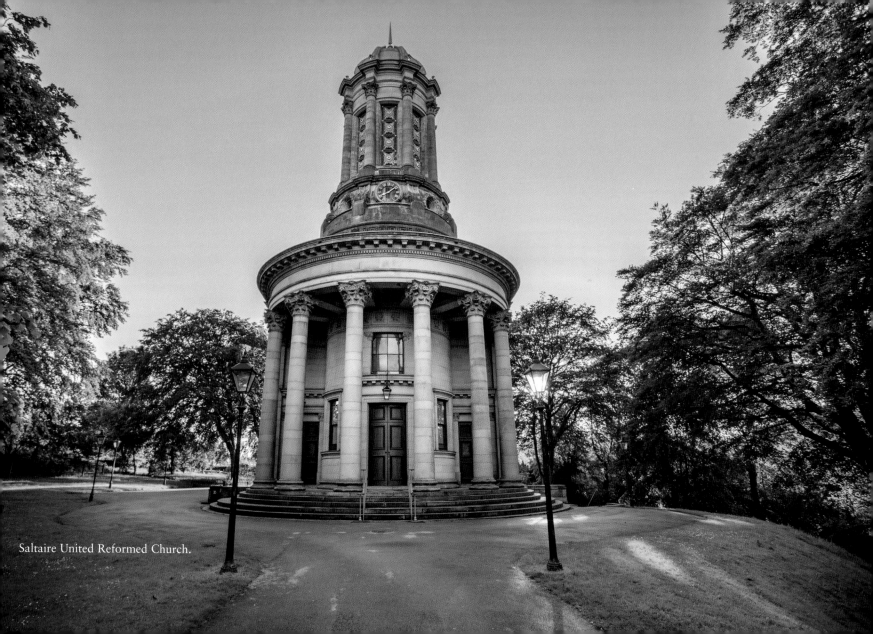

Saltaire United Reformed Church.

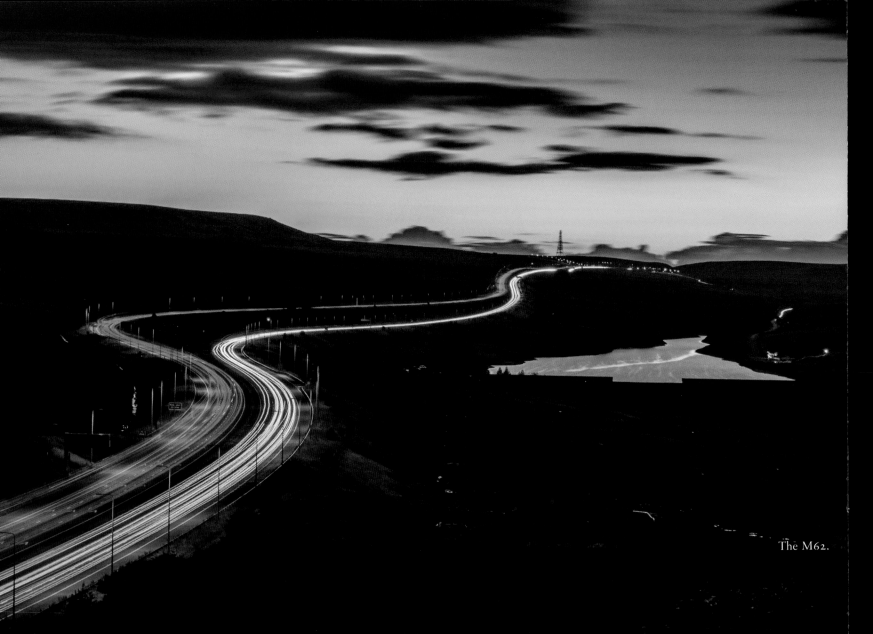

The M62.

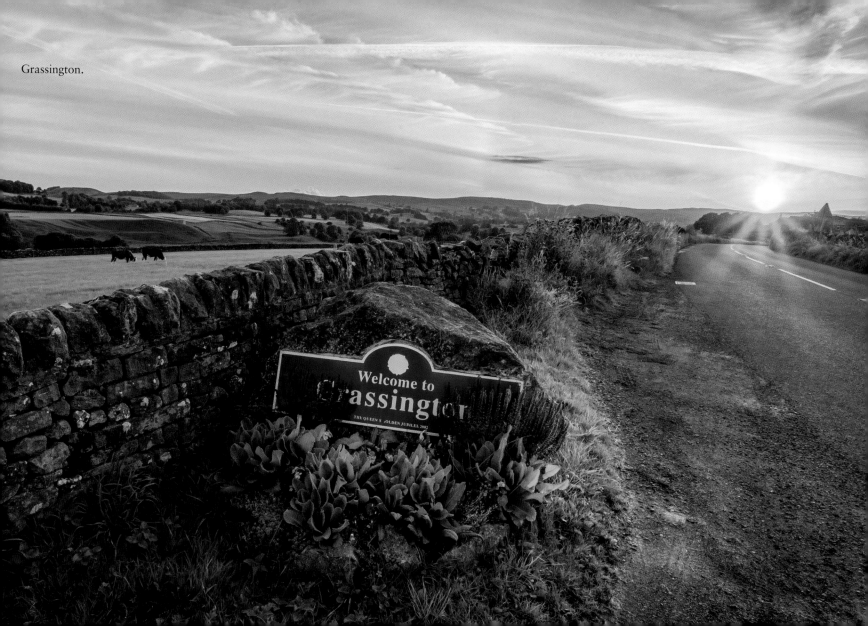

Grassington.

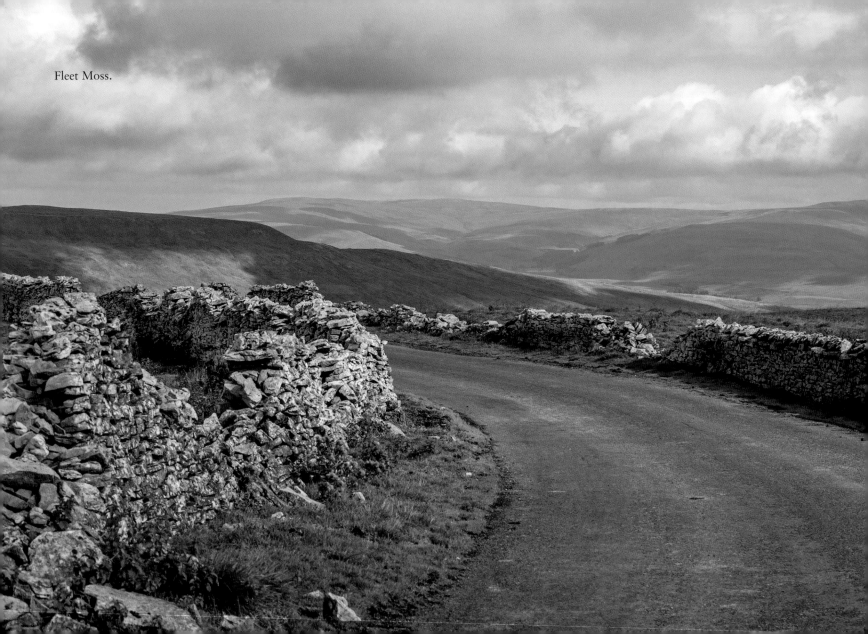

Fleet Moss.

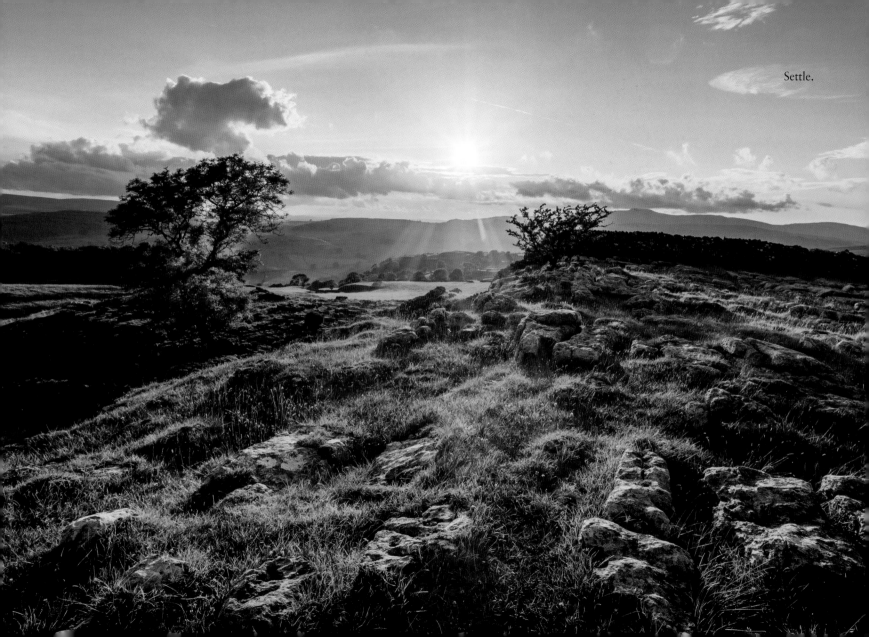

Settle.

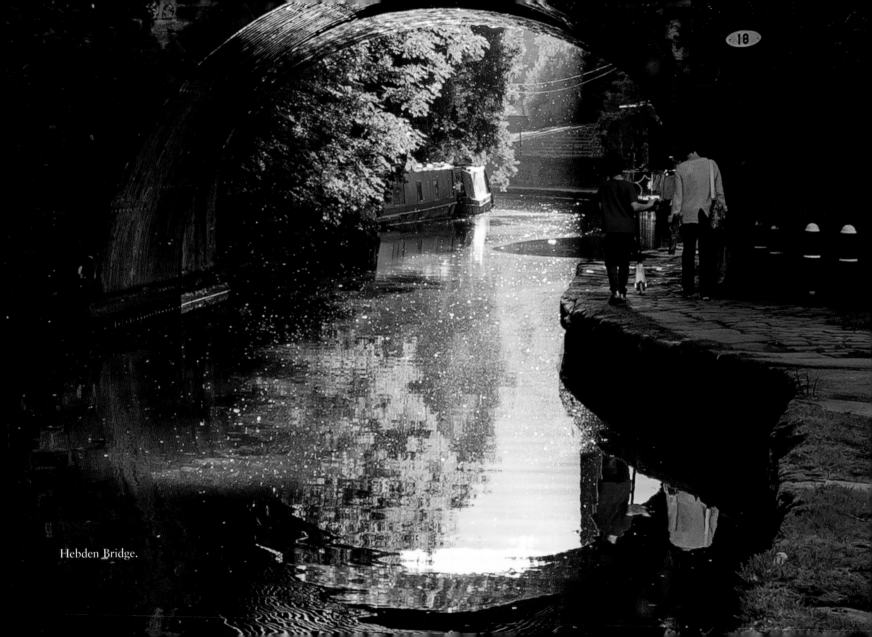

Hebden Bridge.

18

AUTUMN

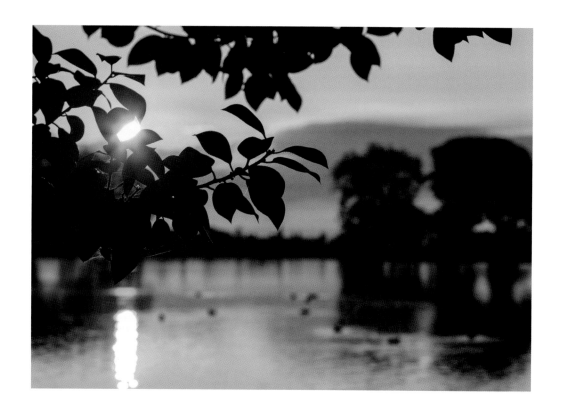

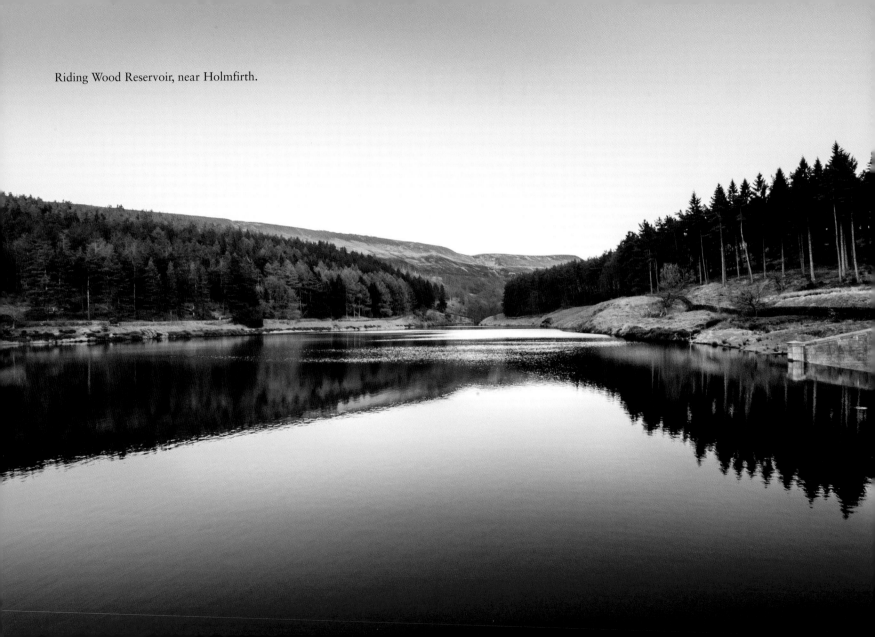

Riding Wood Reservoir, near Holmfirth.

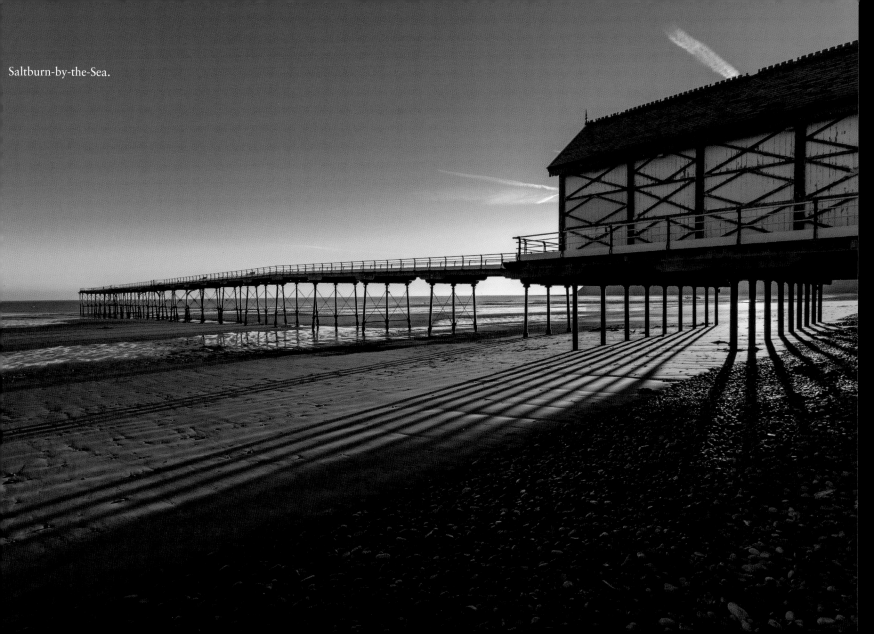

Saltburn-by-the-Sea.

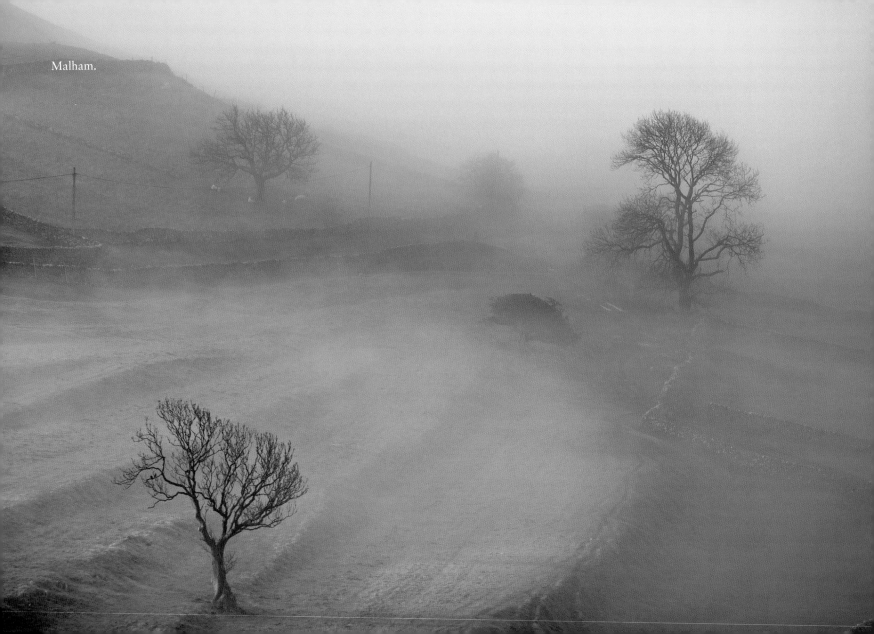

Malham.

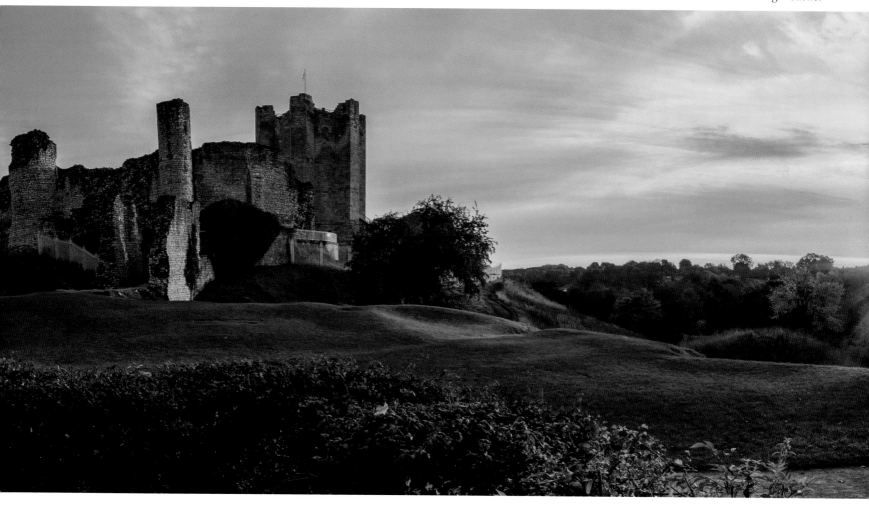

Conisborough Castle.

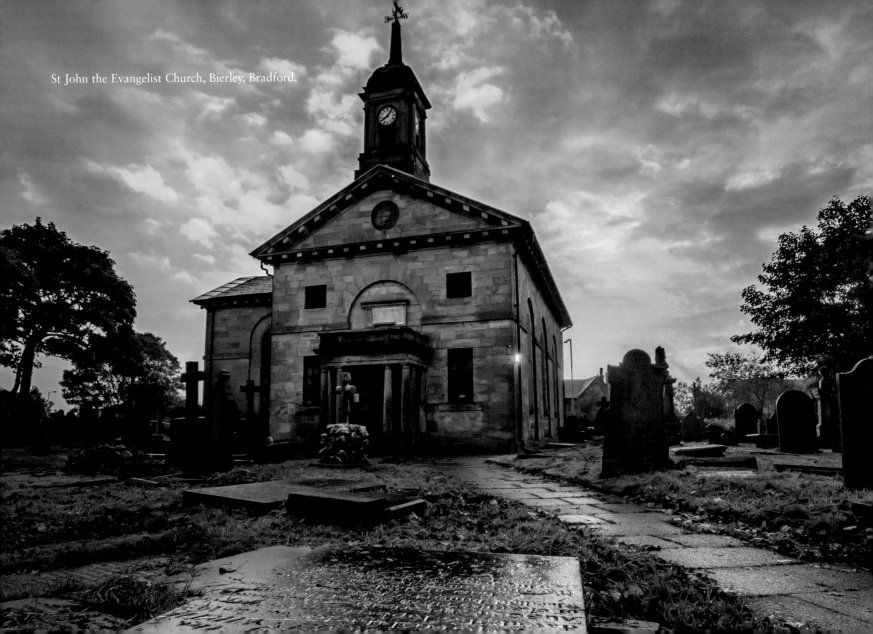

St John the Evangelist Church, Bierley, Bradford.

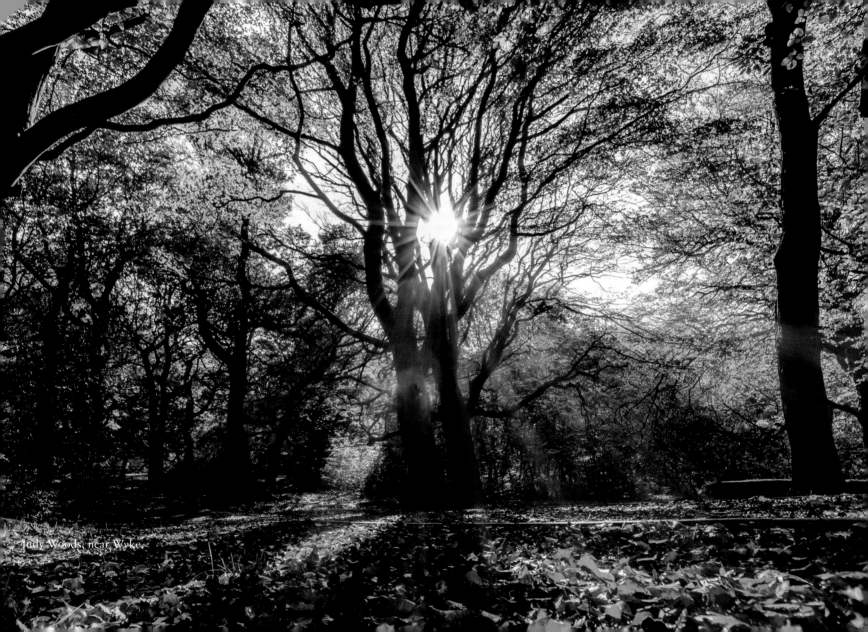

Judy Woods, near Wyke

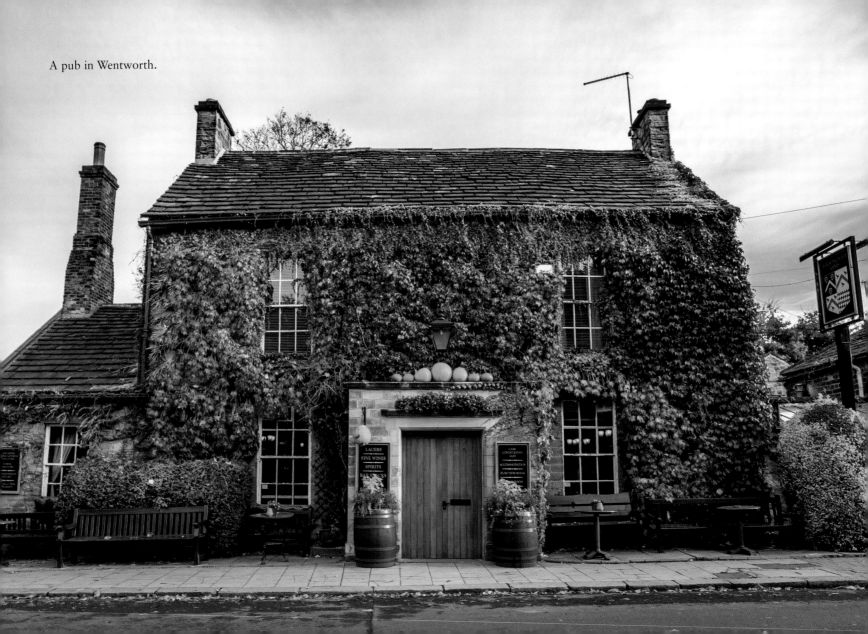

A pub in Wentworth.

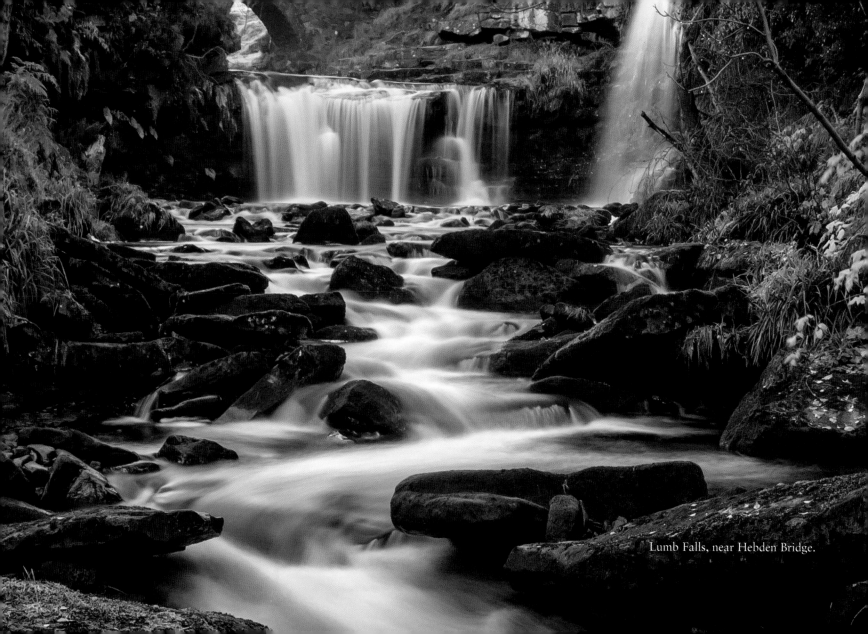

Lumb Falls, near Hebden Bridge.

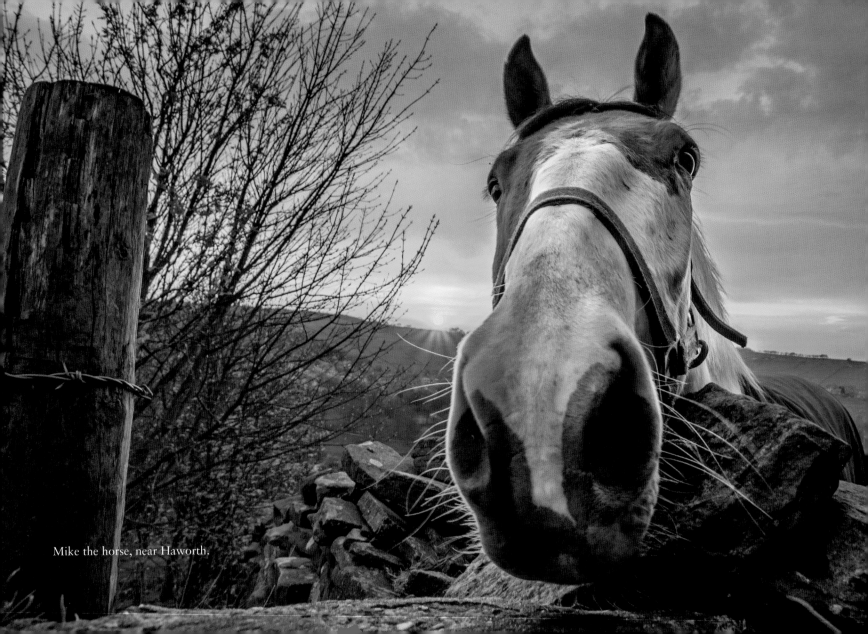

Mike the horse, near Haworth.

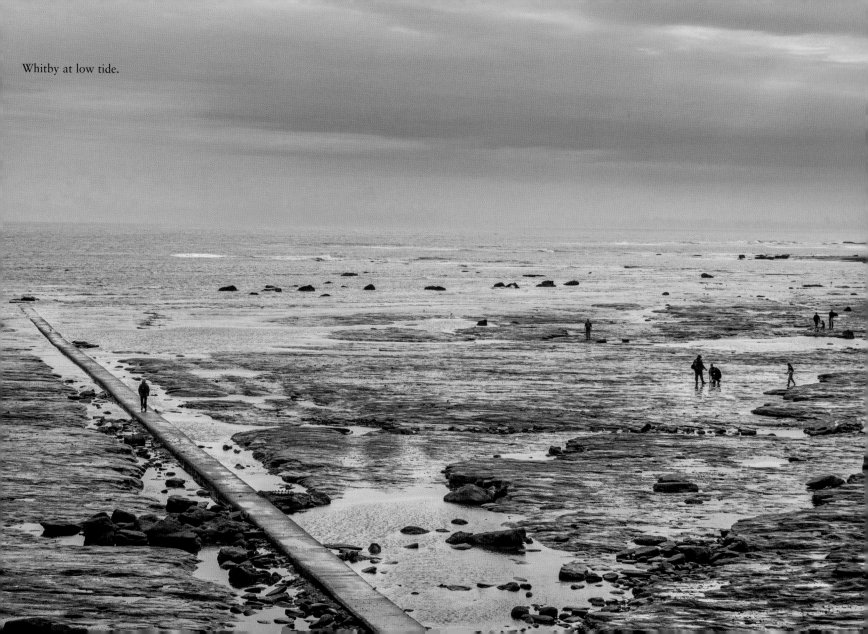

Whitby at low tide.

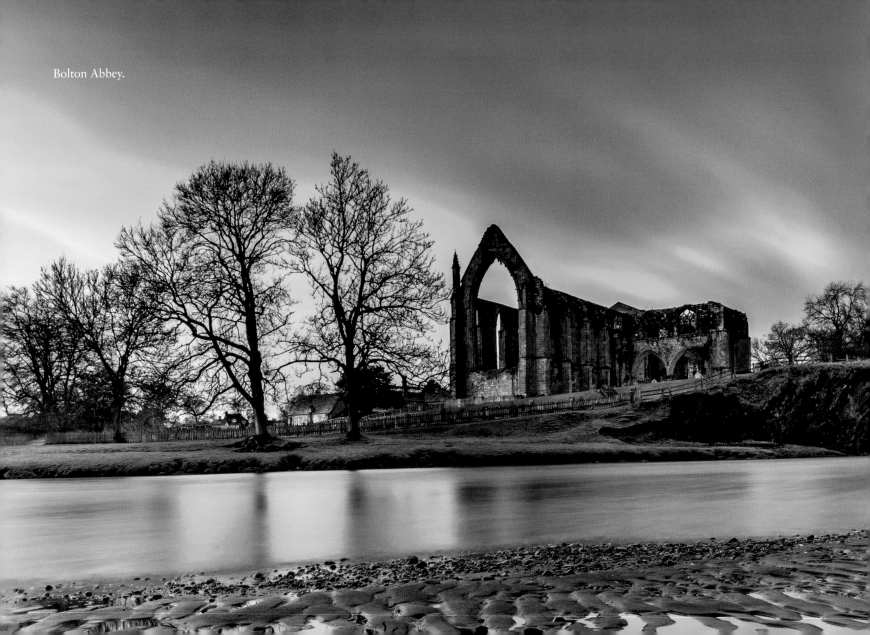
Bolton Abbey.

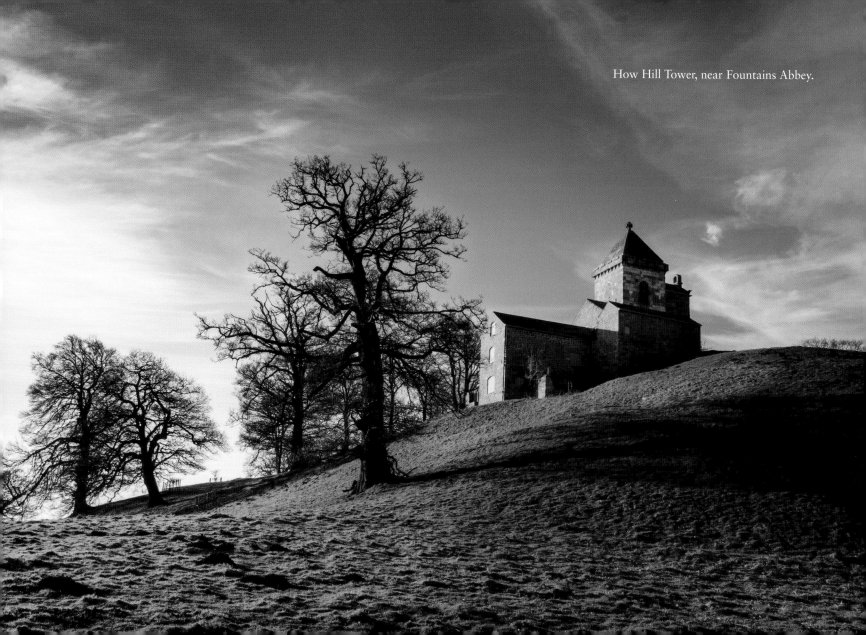

How Hill Tower, near Fountains Abbey.

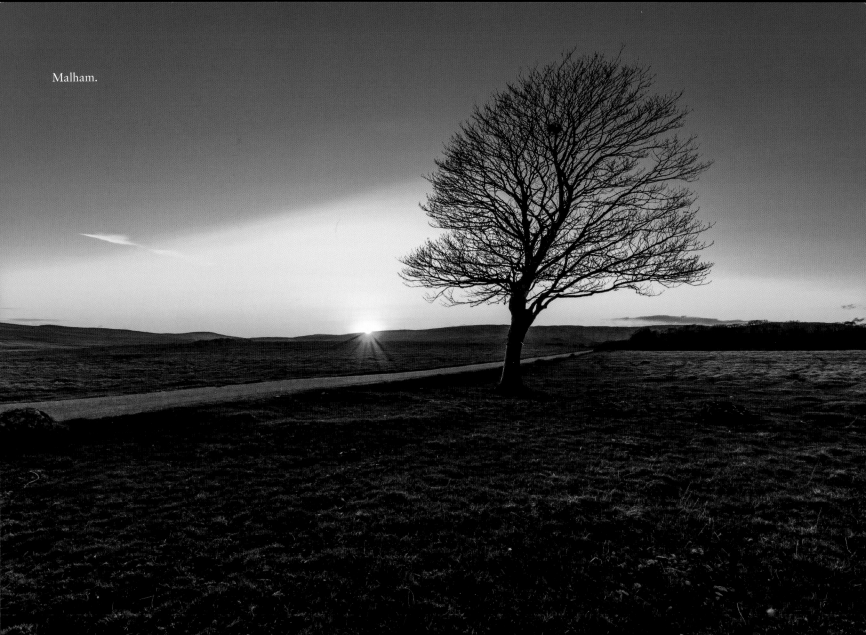

Malham.

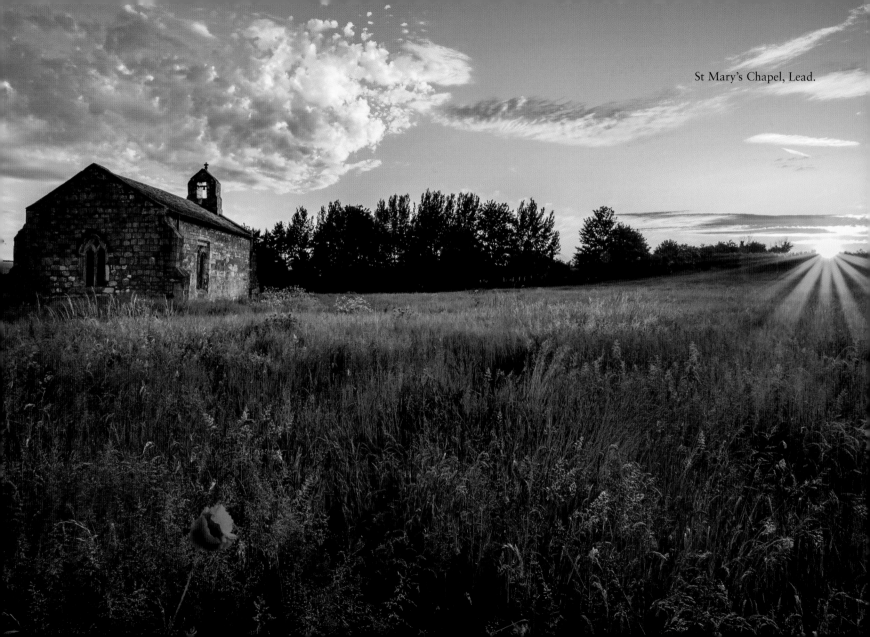

St Mary's Chapel, Lead.

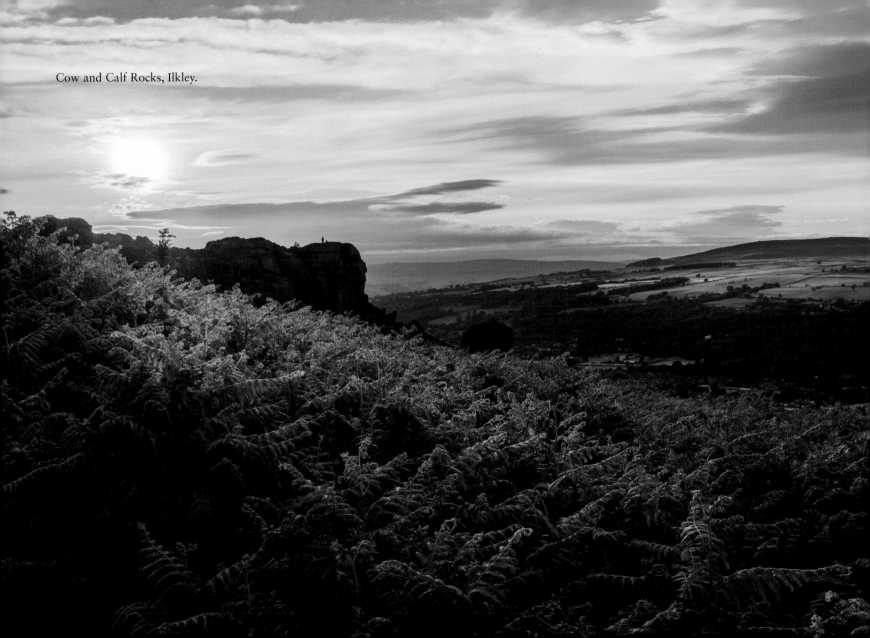

Cow and Calf Rocks, Ilkley.

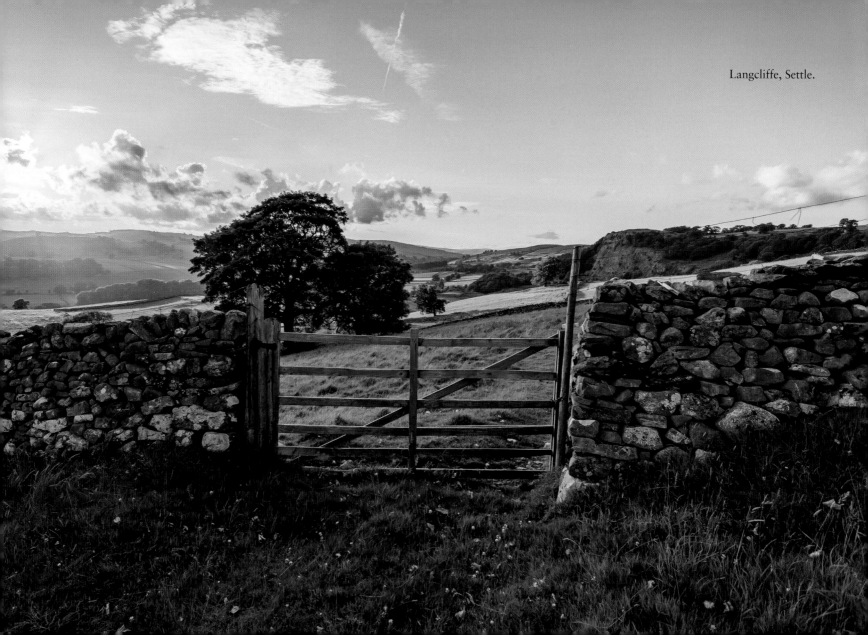

Langcliffe, Settle.

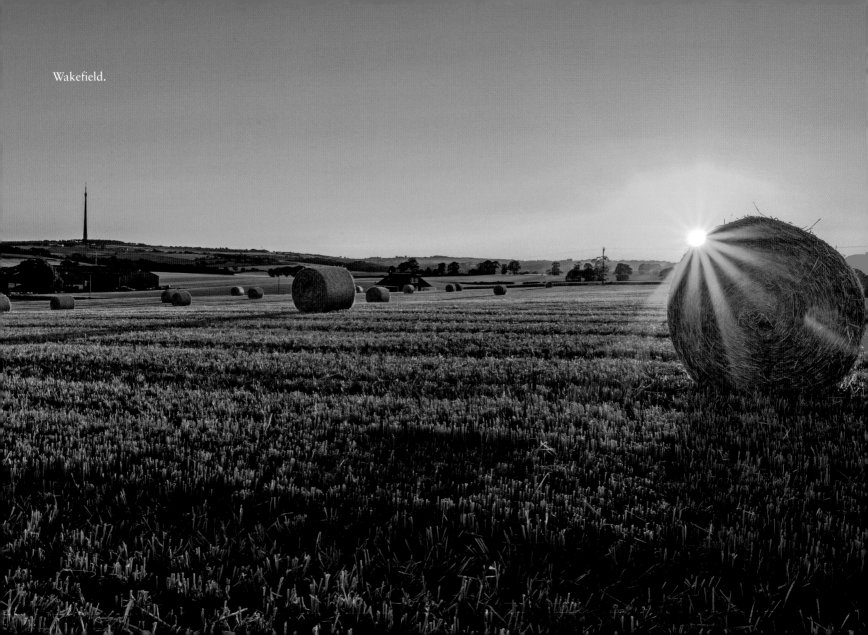

Wakefield.

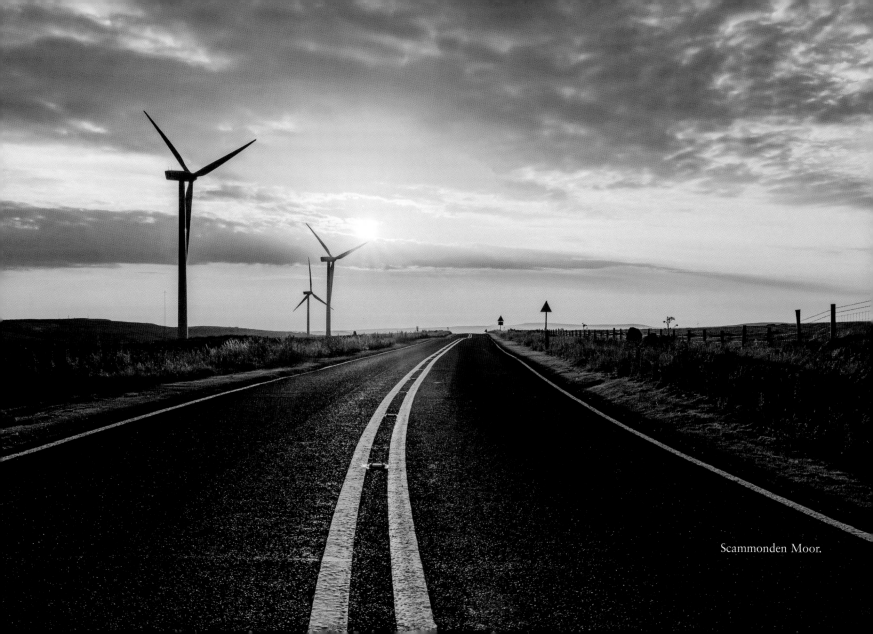
Scammonden Moor.

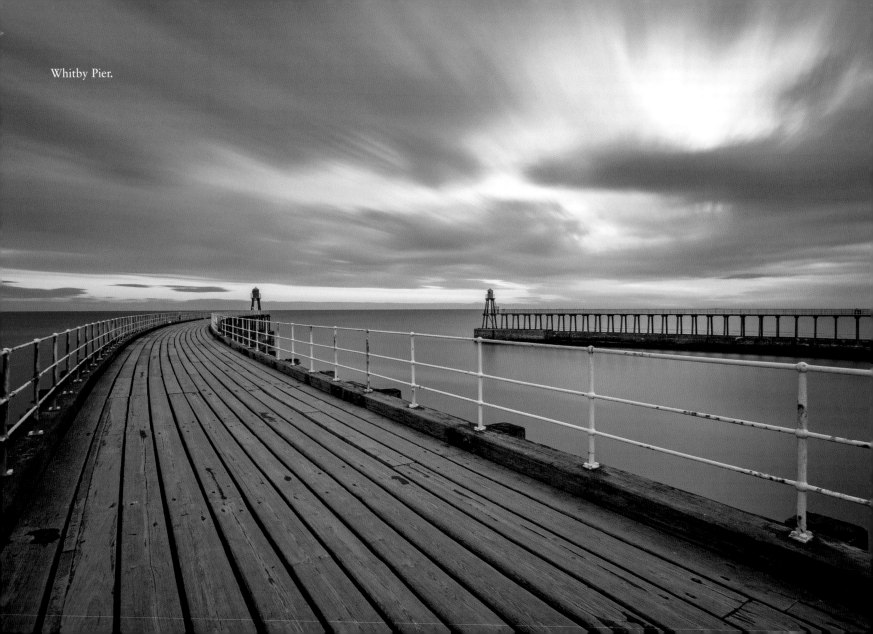

Whitby Pier.

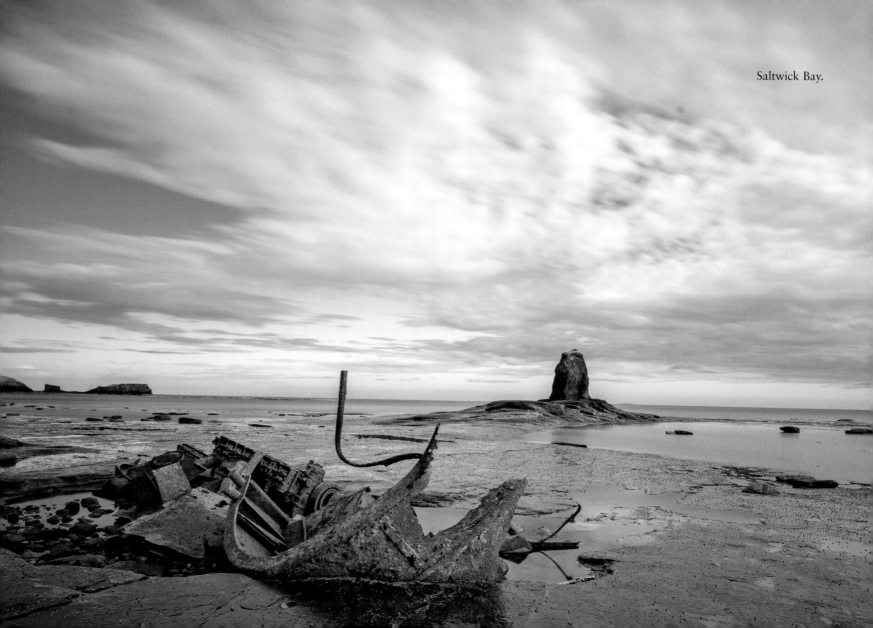

Saltwick Bay.

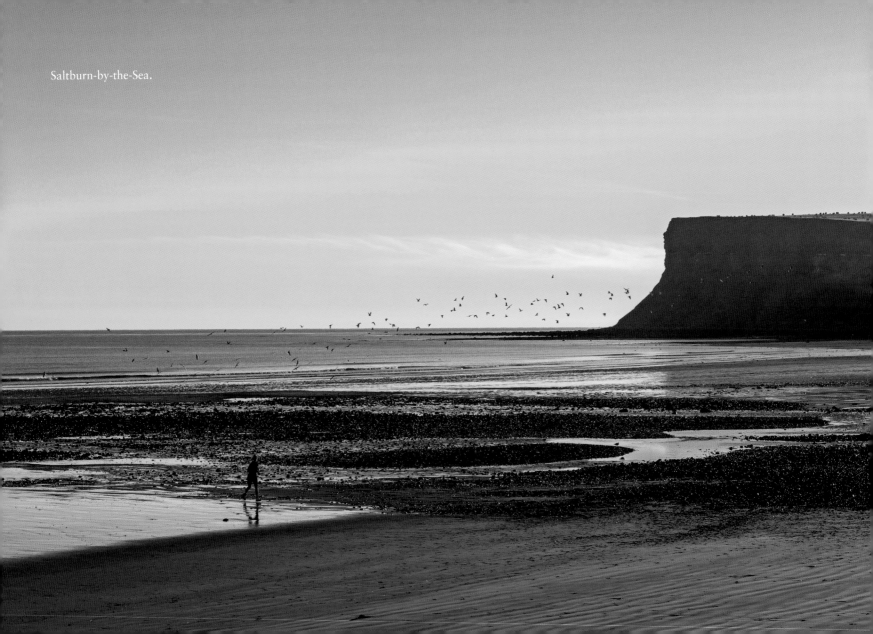

Saltburn-by-the-Sea.

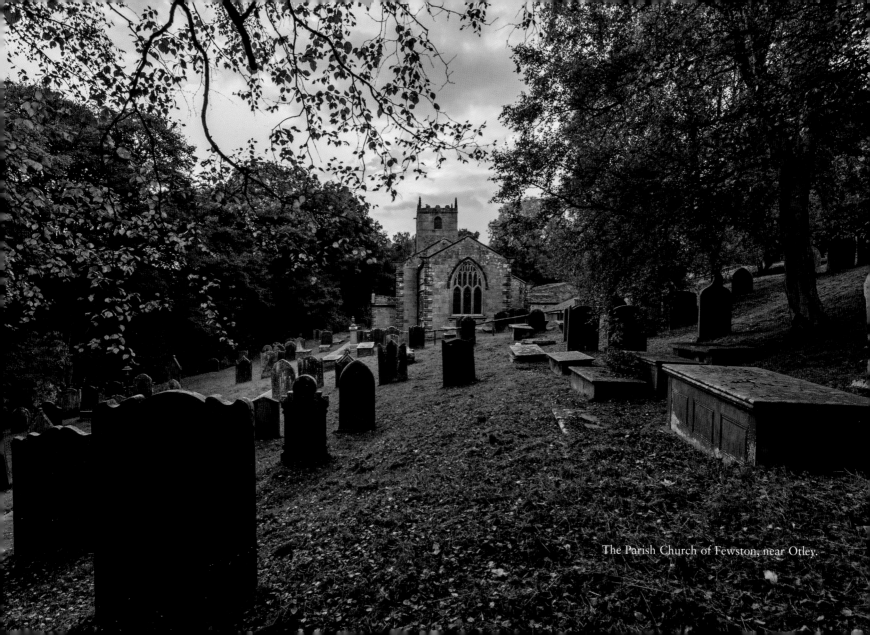

The Parish Church of Fewston, near Otley.

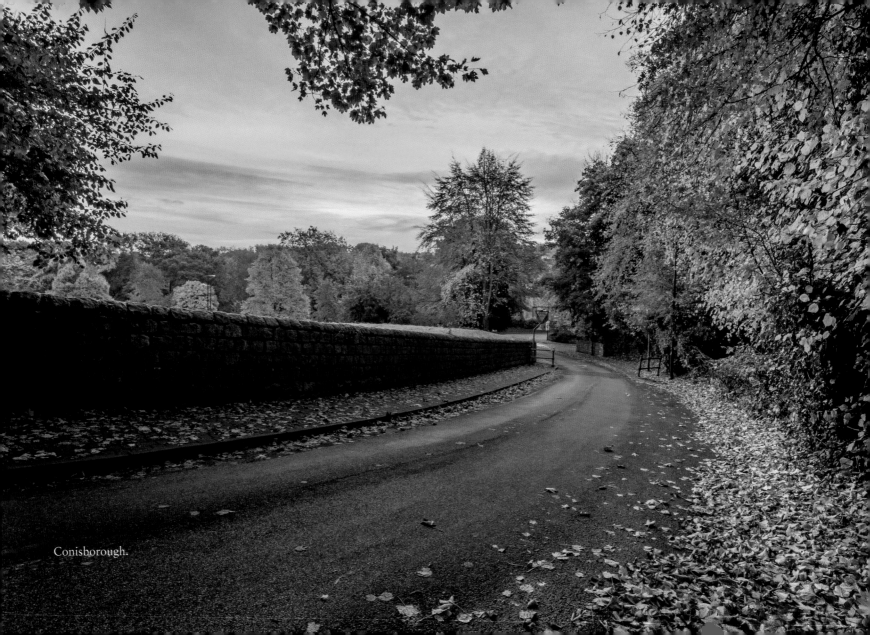

Conisborough.

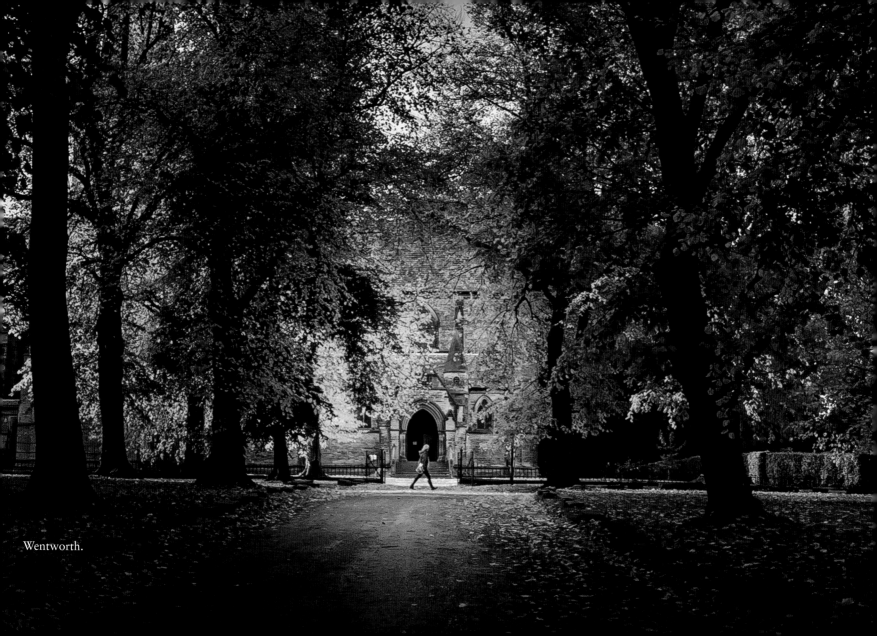

Wentworth.

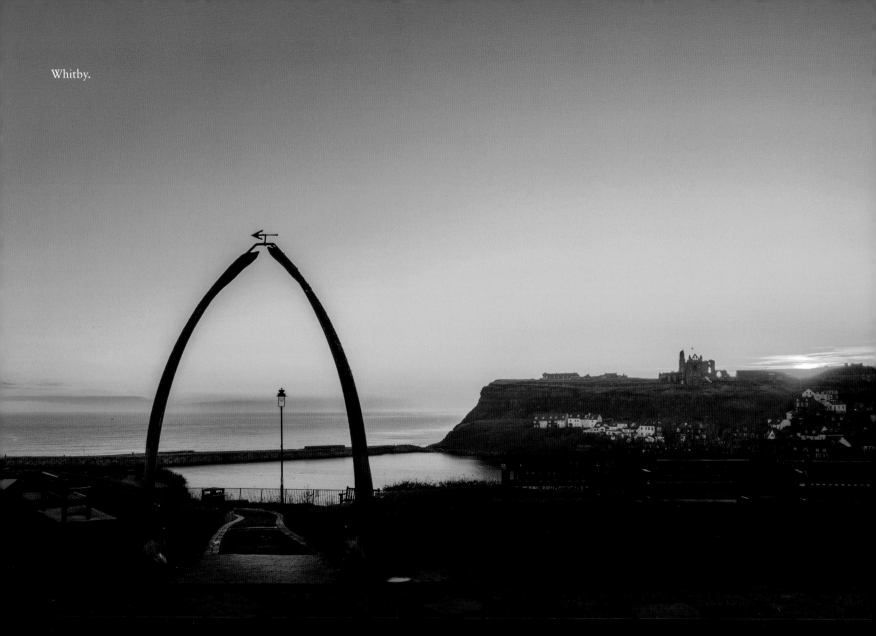

Whitby.

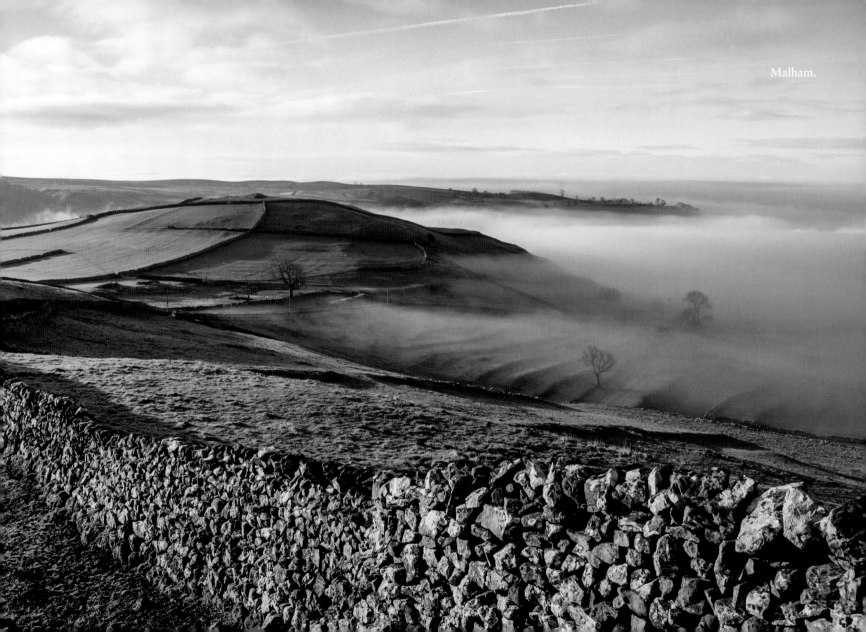

Malham.

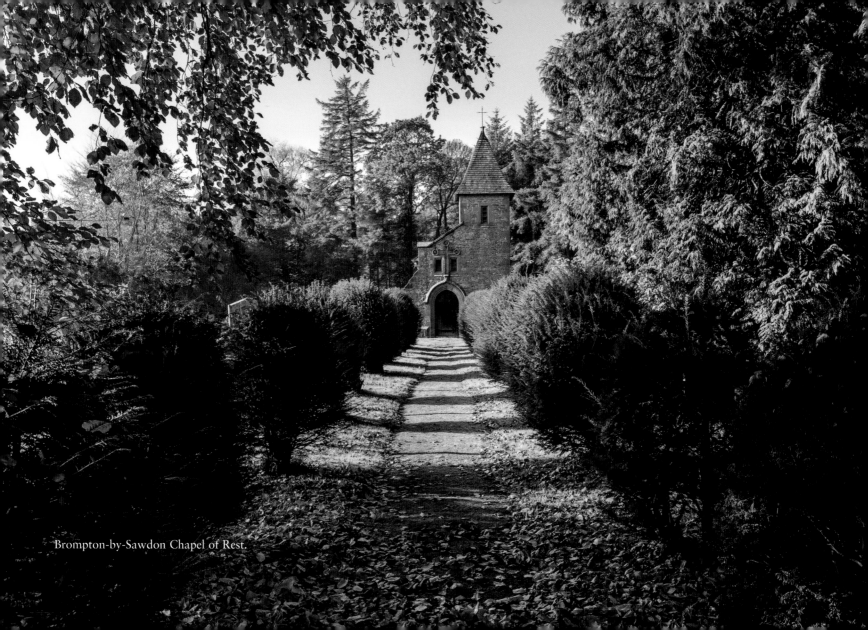

Brompton-by-Sawdon Chapel of Rest.

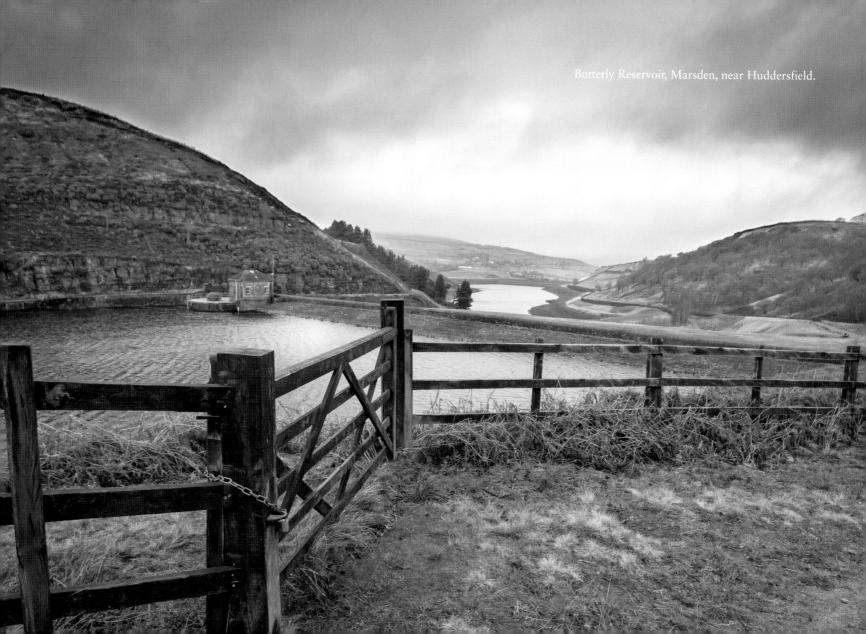

Butterly Reservoir, Marsden, near Huddersfield.

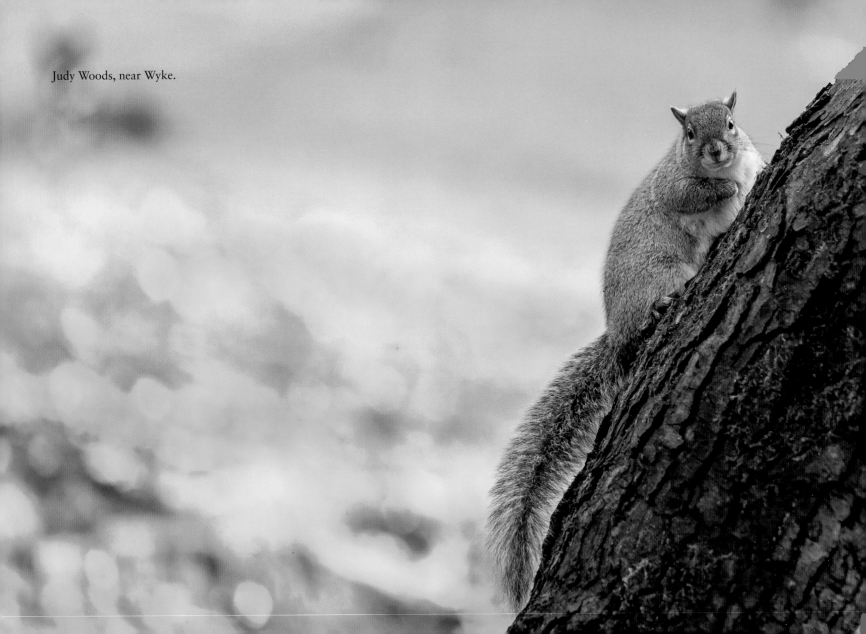

Judy Woods, near Wyke.

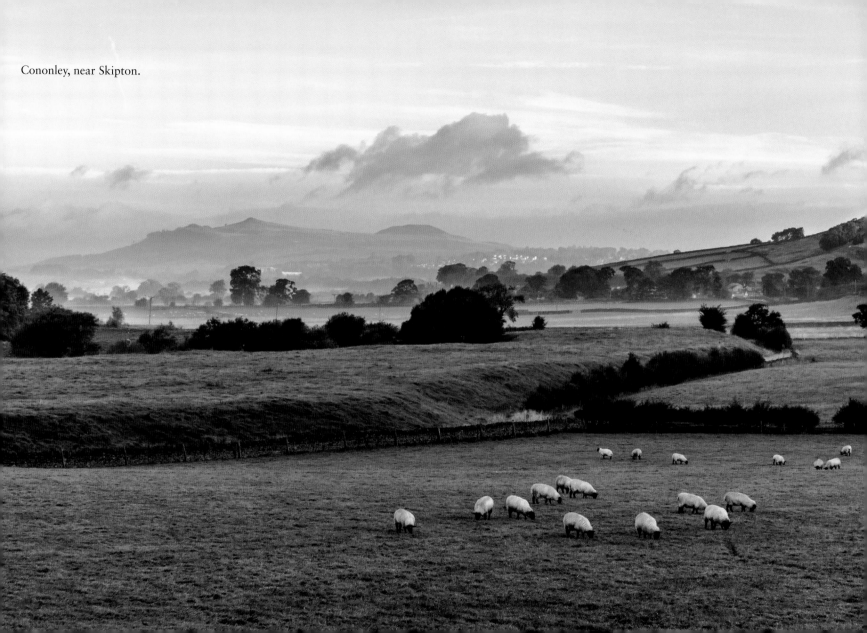

Cononley, near Skipton.

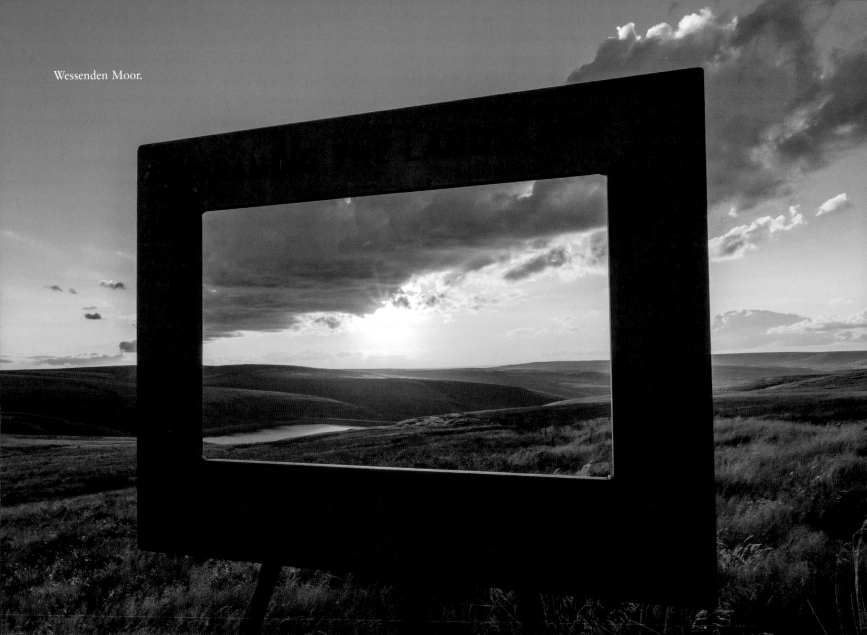

Wessenden Moor.

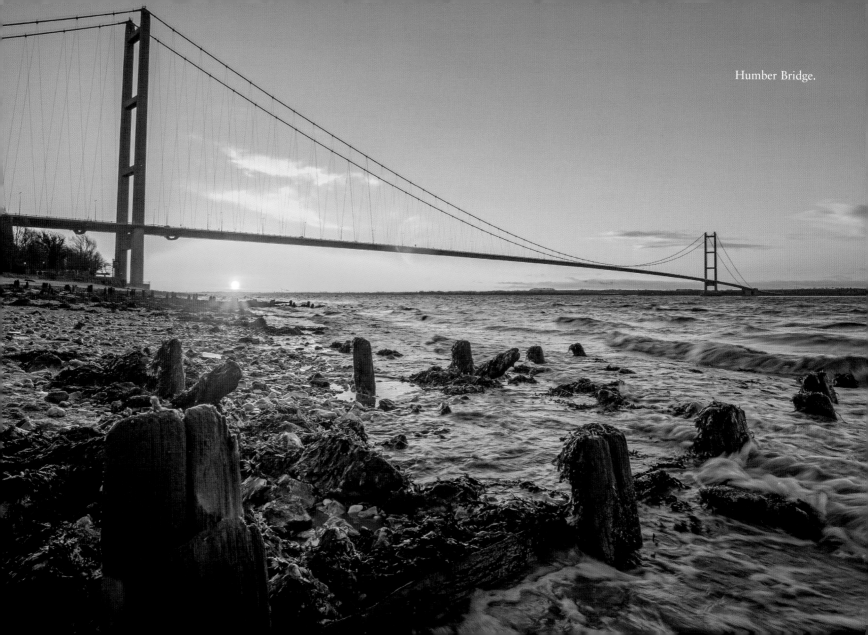

Humber Bridge.

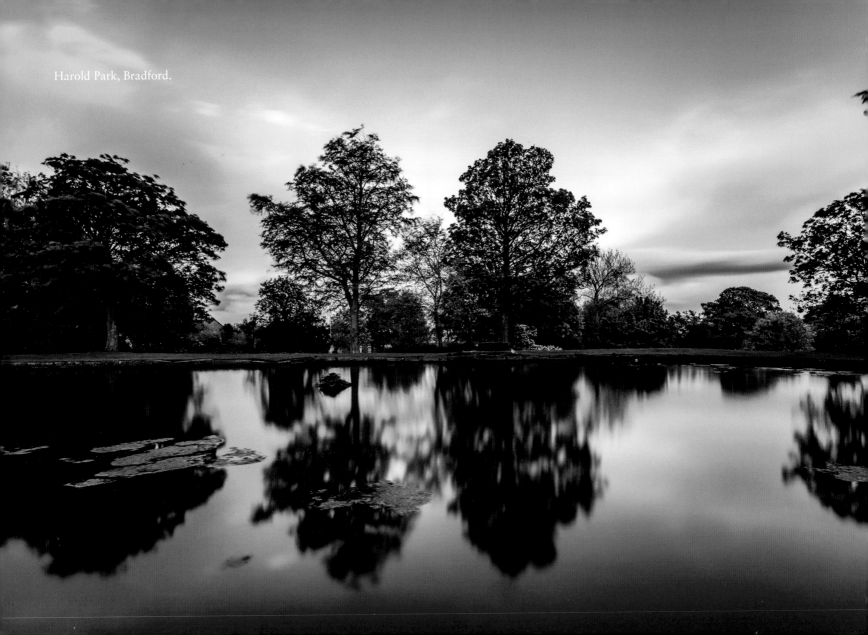

Harold Park, Bradford.

WINTER

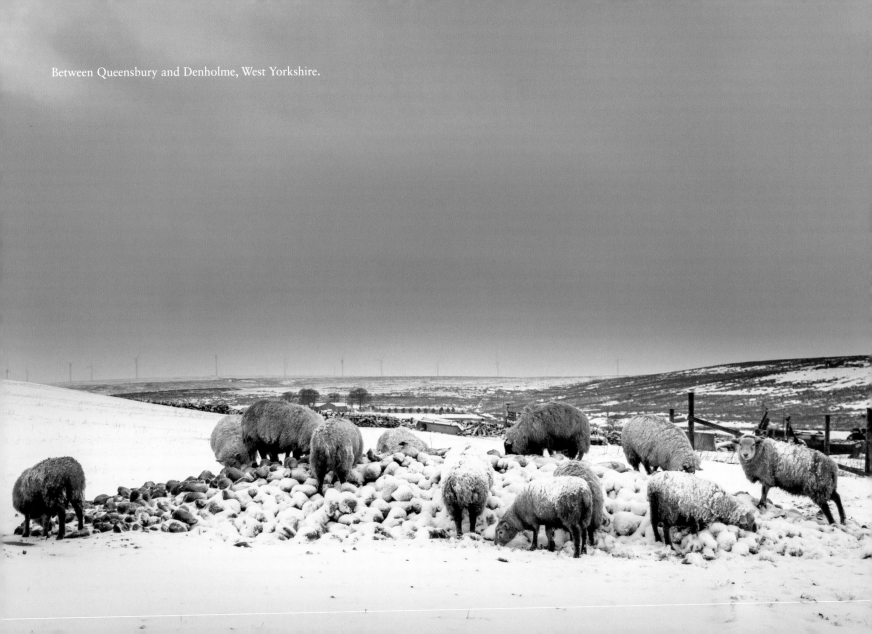

Between Queensbury and Denholme, West Yorkshire.

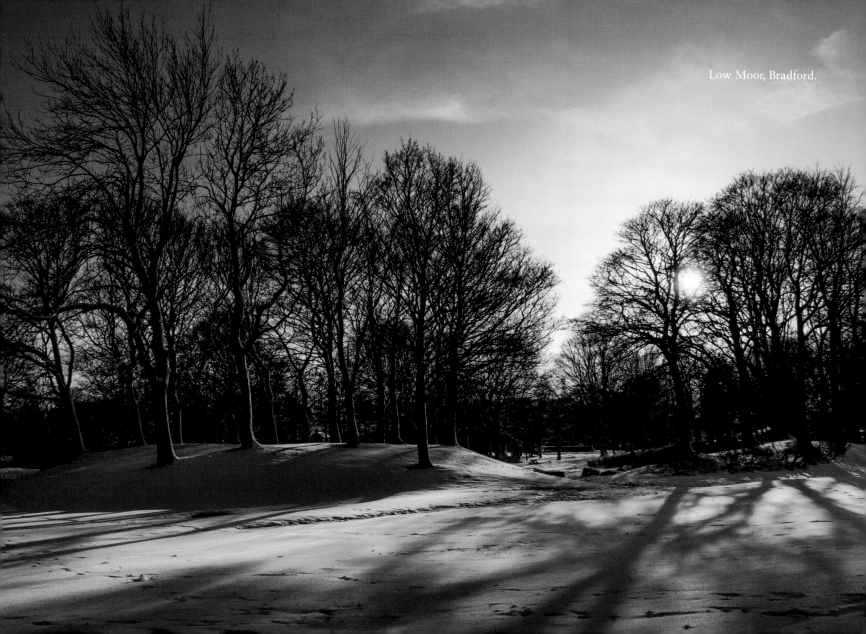

Low Moor, Bradford.

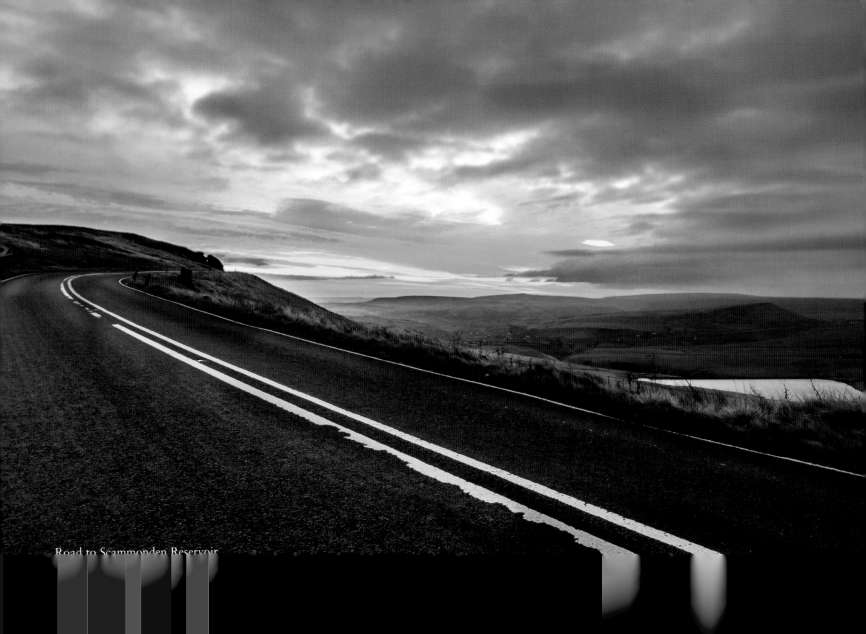

Road to Scammonden Reservoir

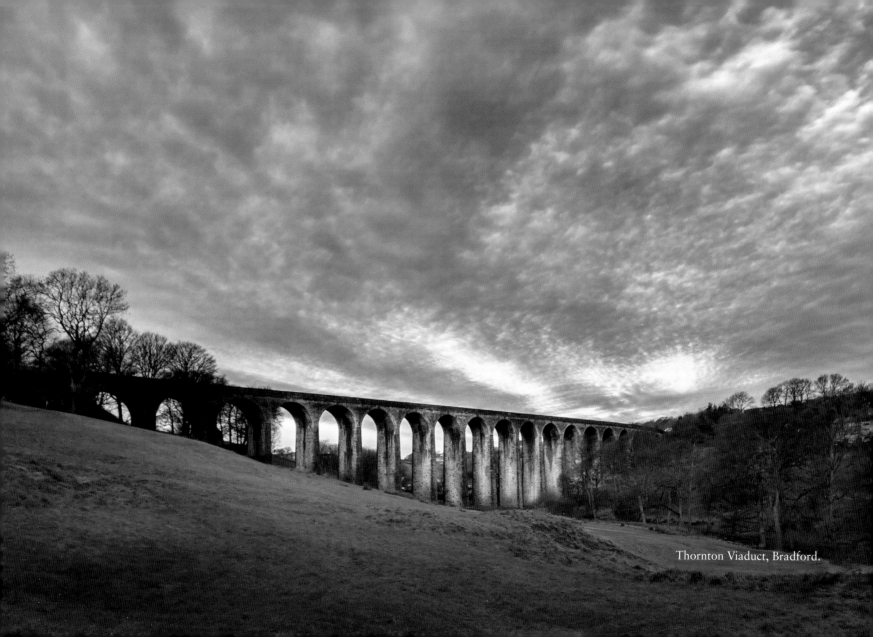

Thornton Viaduct, Bradford.

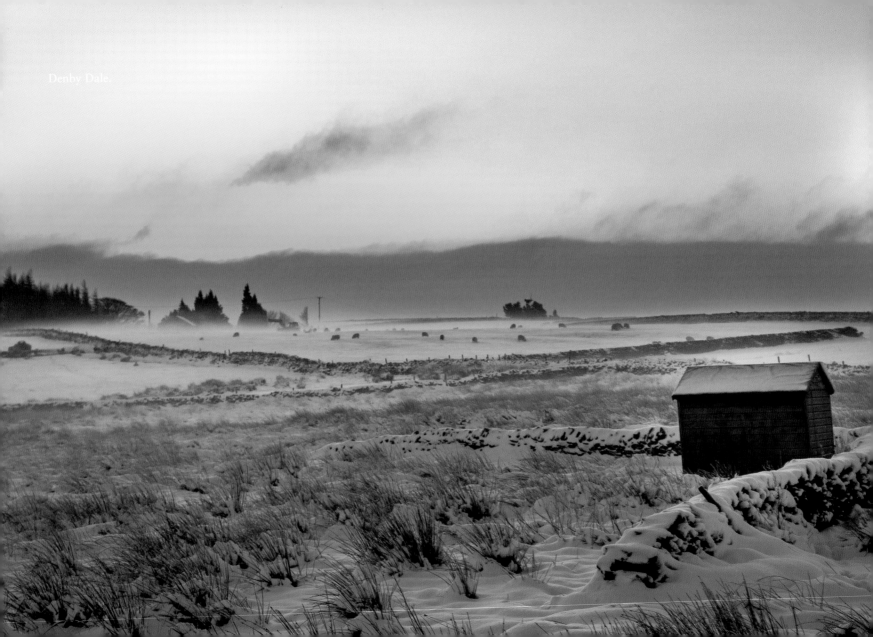

Denby Dale.

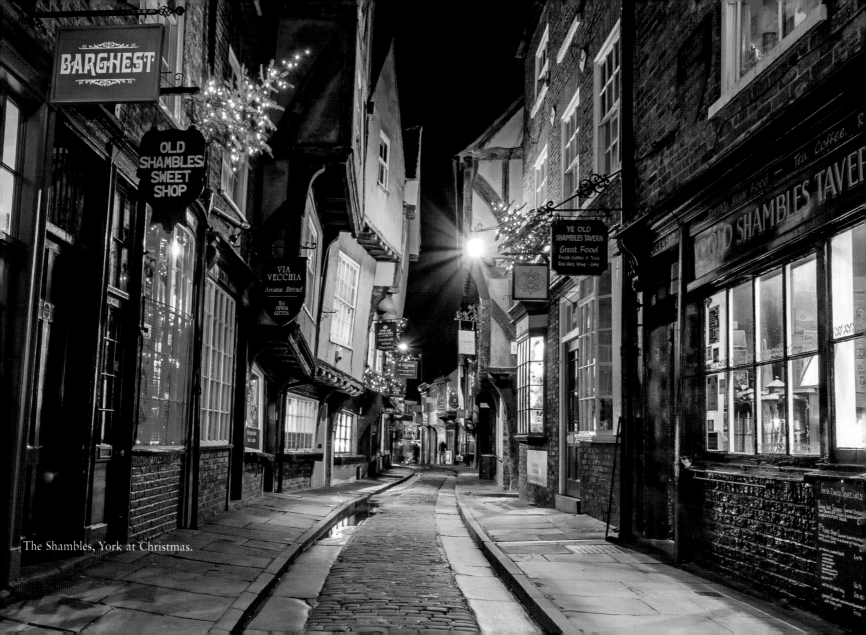

The Shambles, York at Christmas.

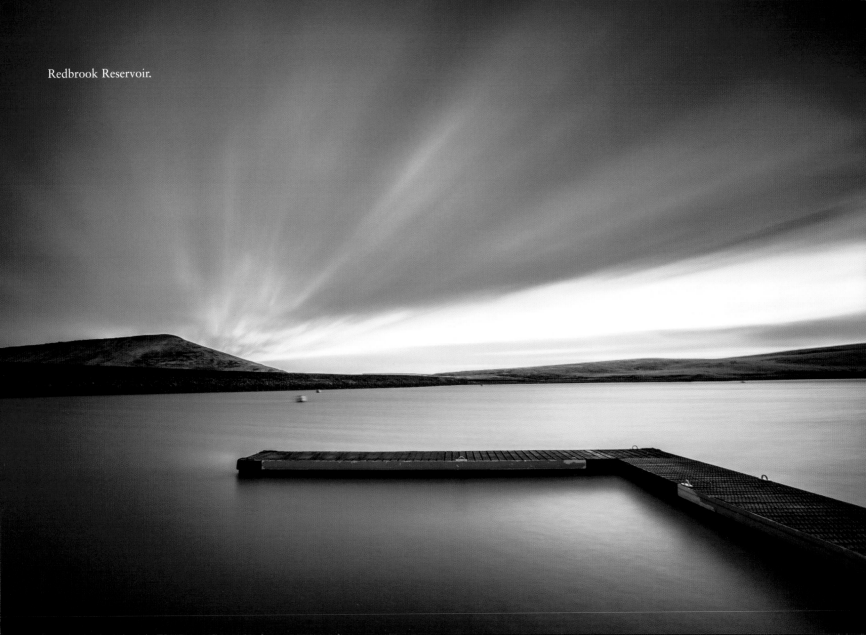

Redbrook Reservoir.

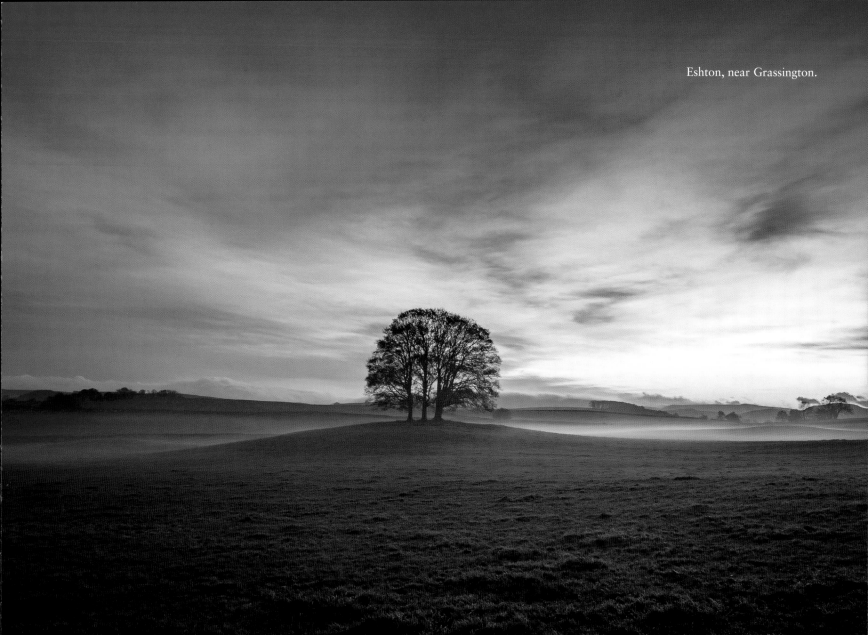

Eshton, near Grassington.

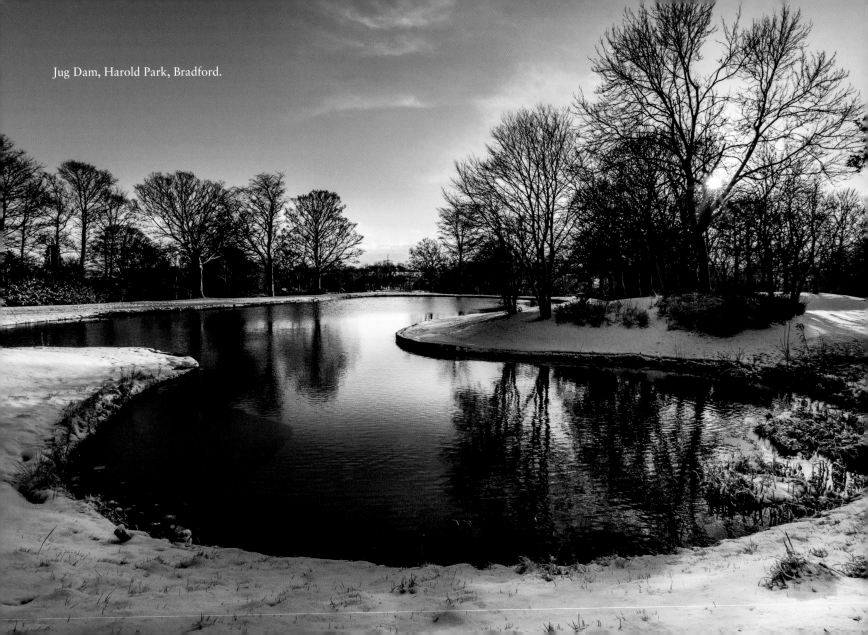

Jug Dam, Harold Park, Bradford.

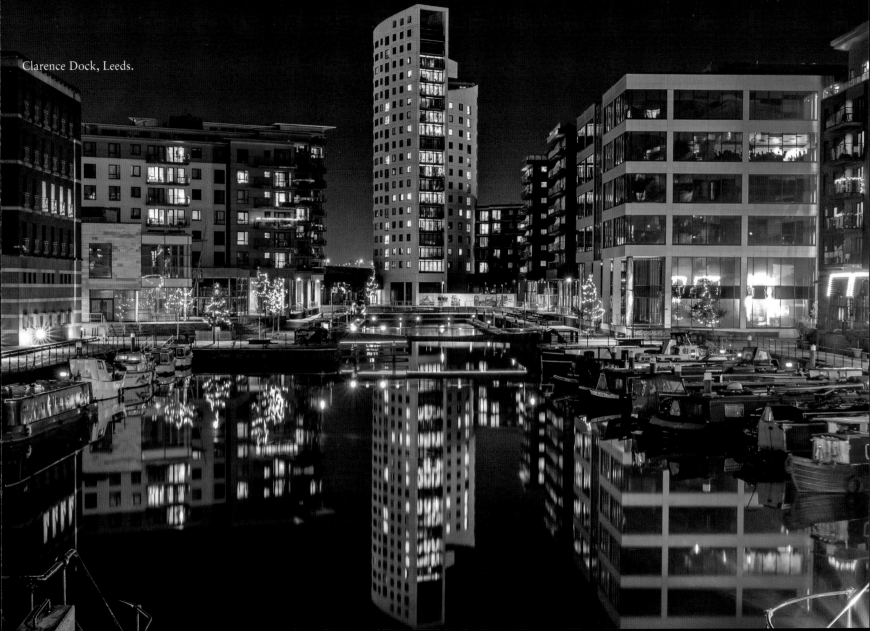

Clarence Dock, Leeds.

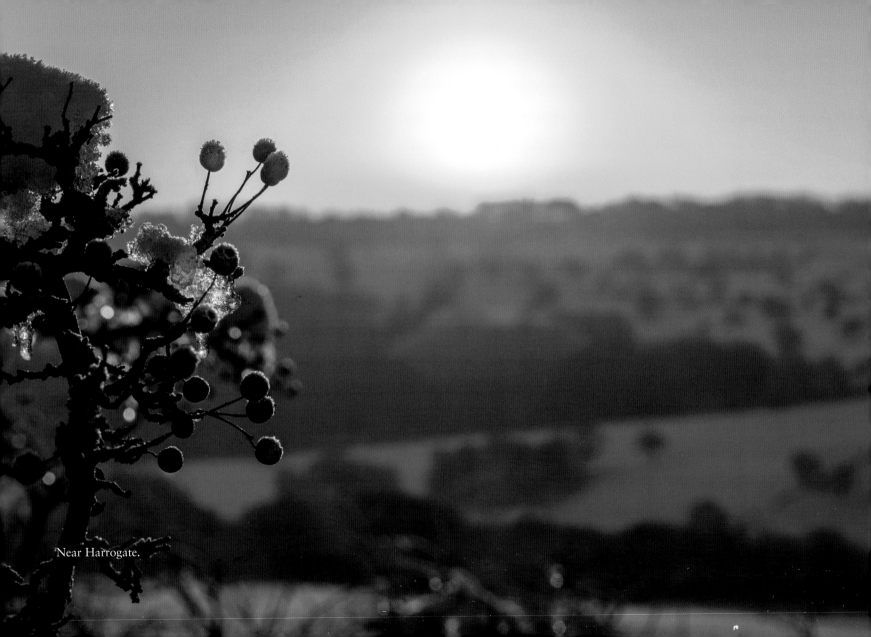

Near Harrogate.

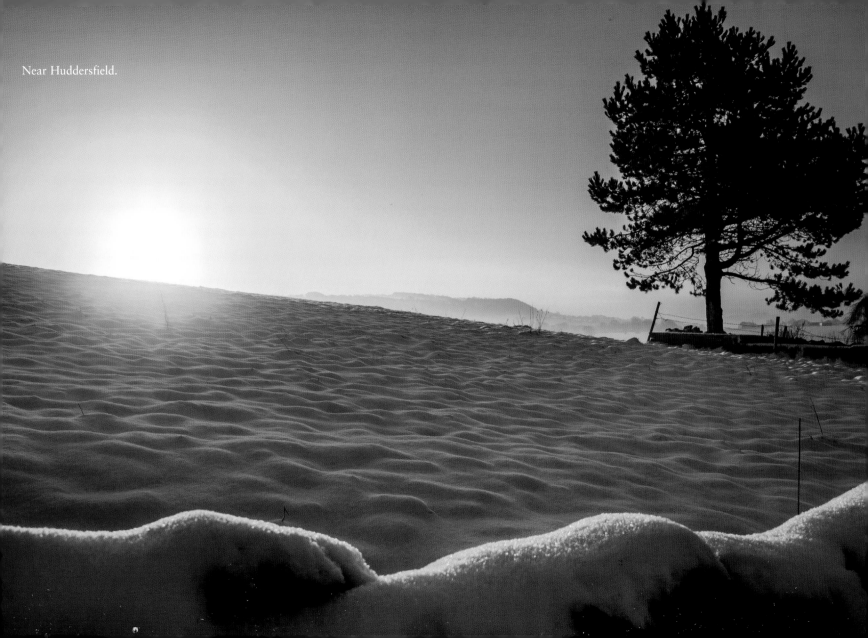

Near Huddersfield.

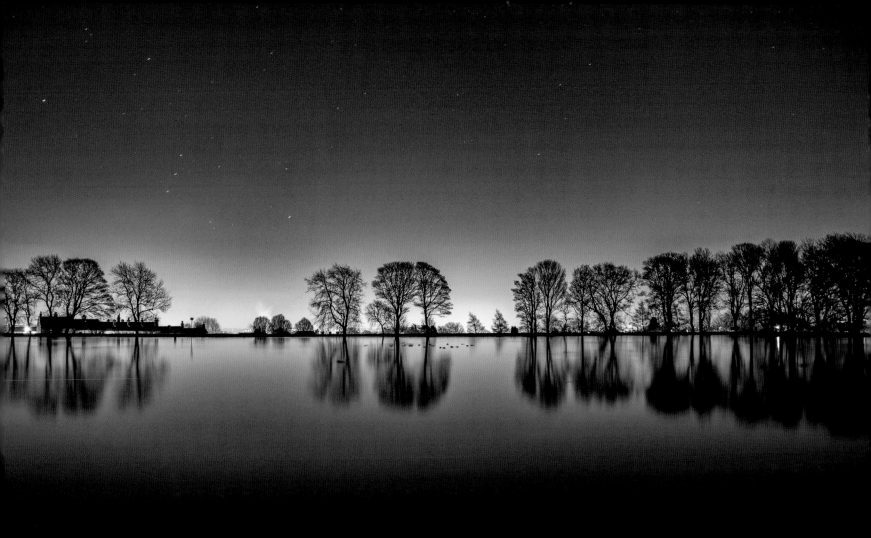

Low Moor, Bradford.

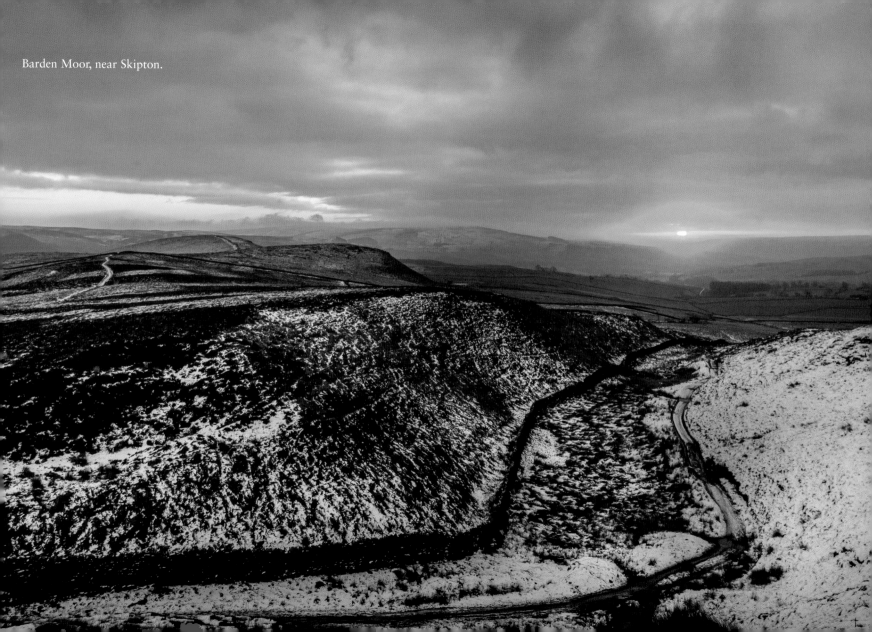

Barden Moor, near Skipton.

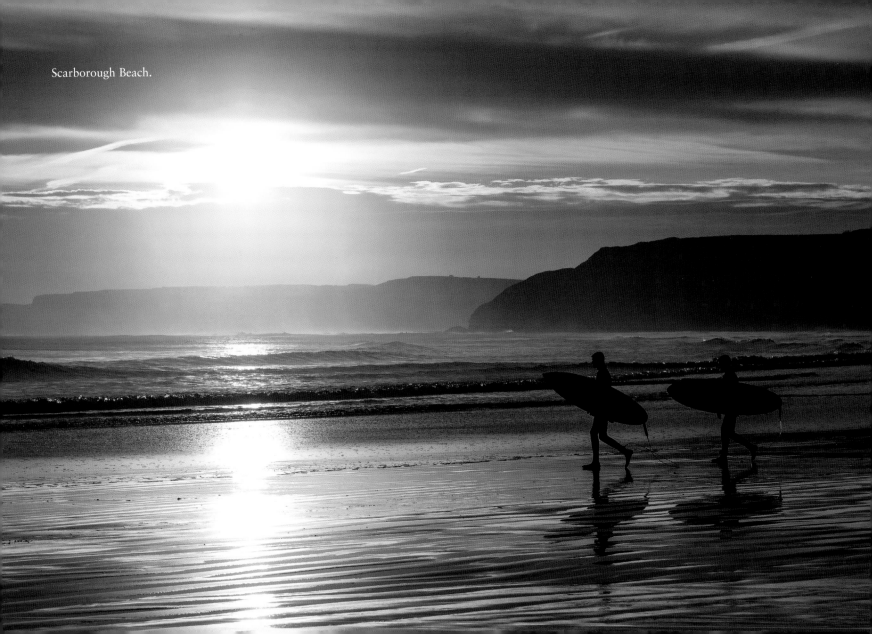

Scarborough Beach.

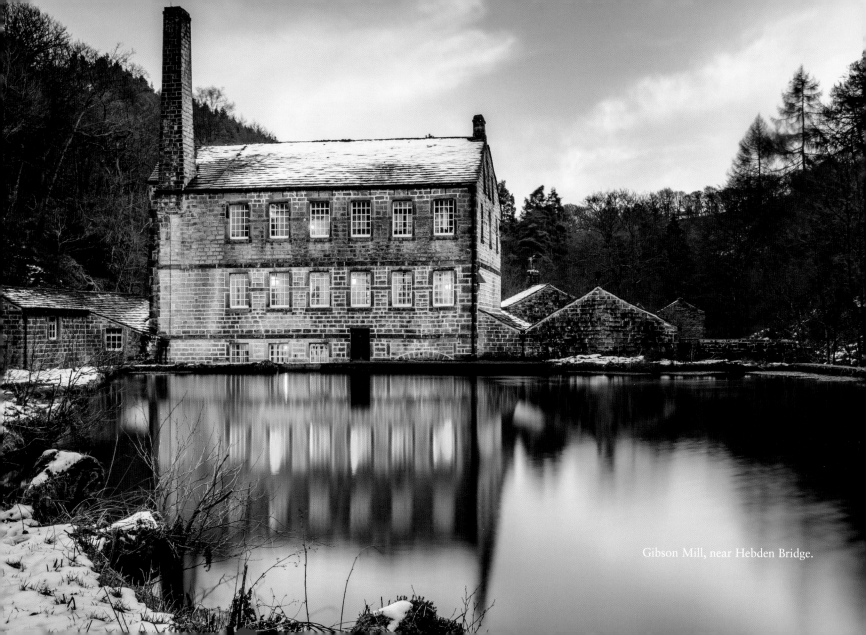

Gibson Mill, near Hebden Bridge.

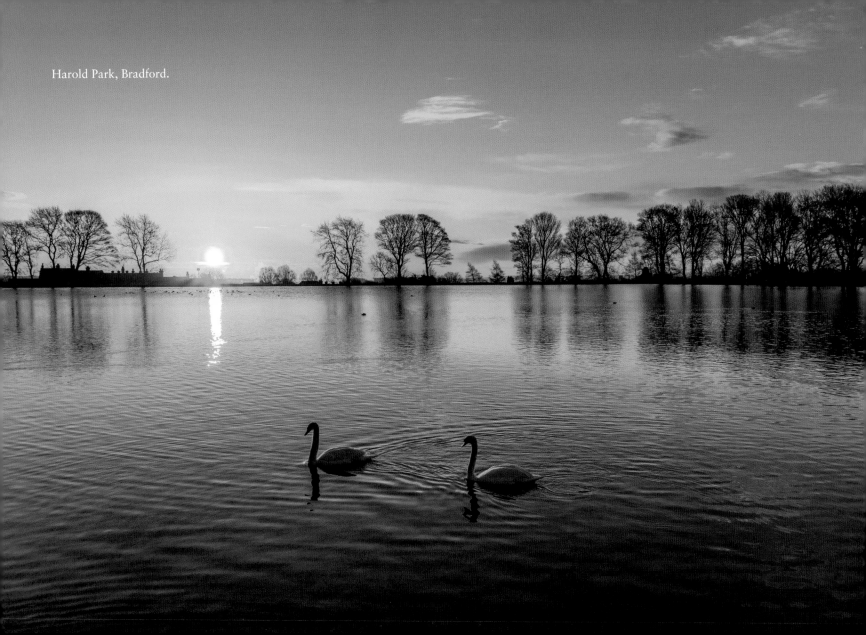

Harold Park, Bradford.

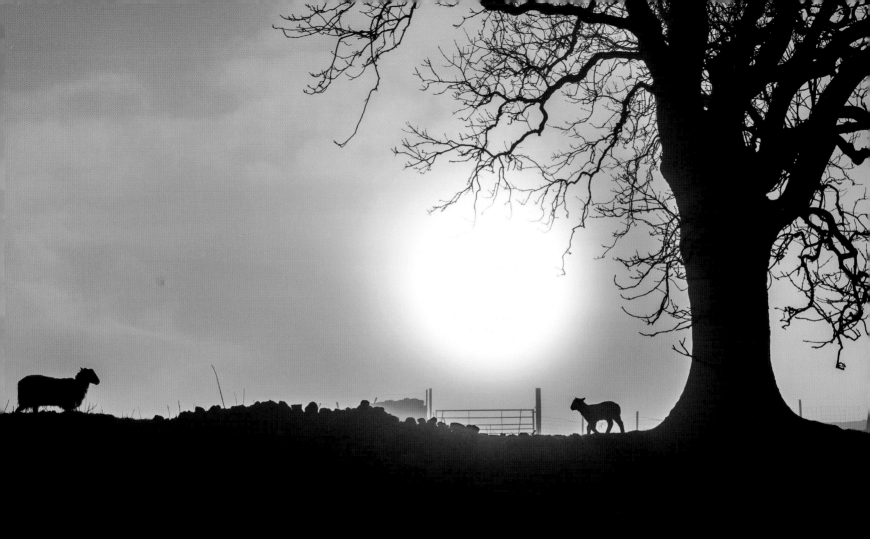

Malham.

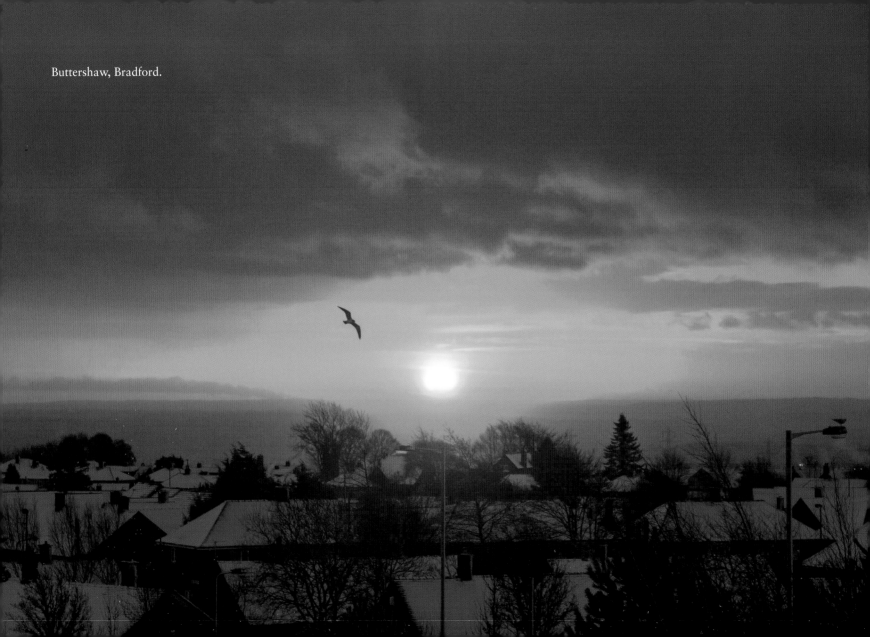

Buttershaw, Bradford.

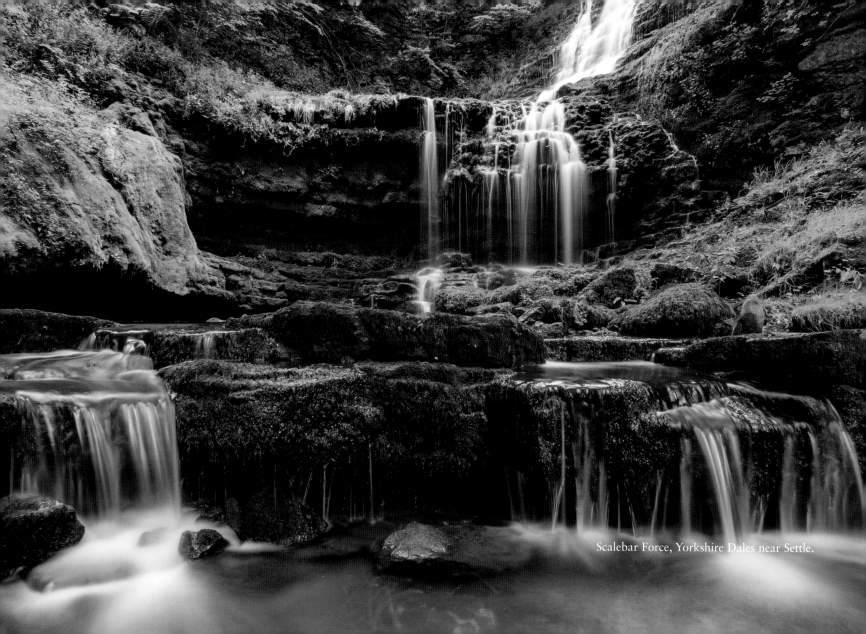

Scalebar Force, Yorkshire Dales near Settle.

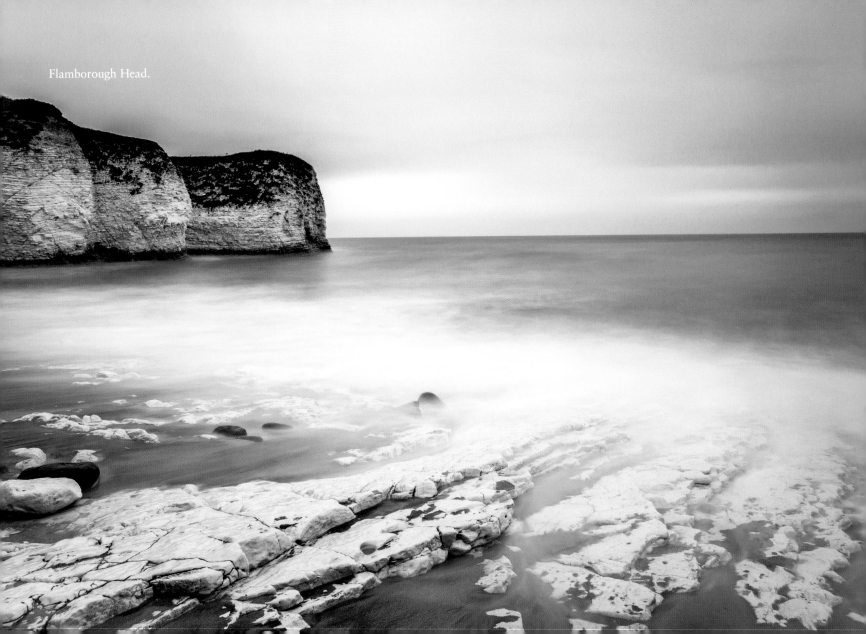

Flamborough Head.

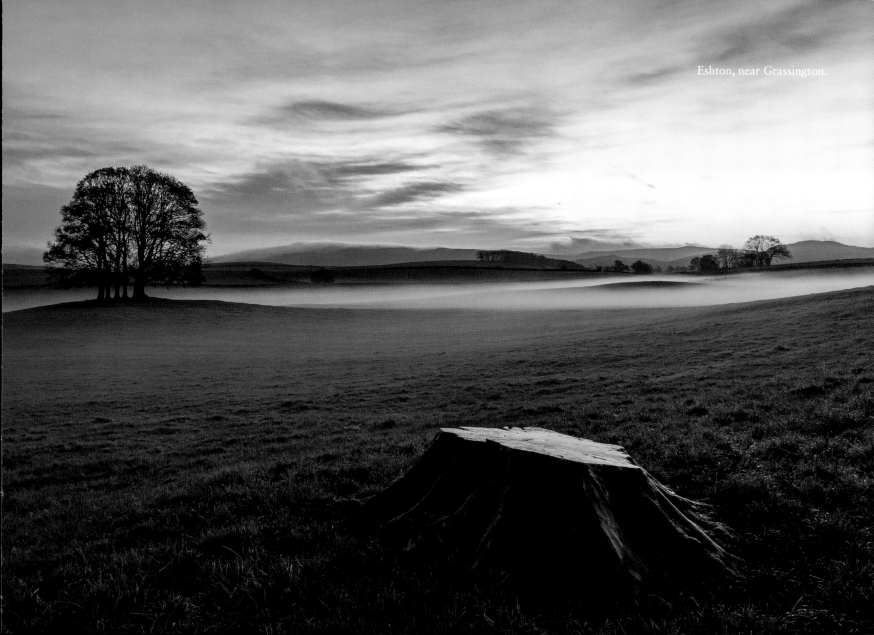

Eshton, near Grassington.

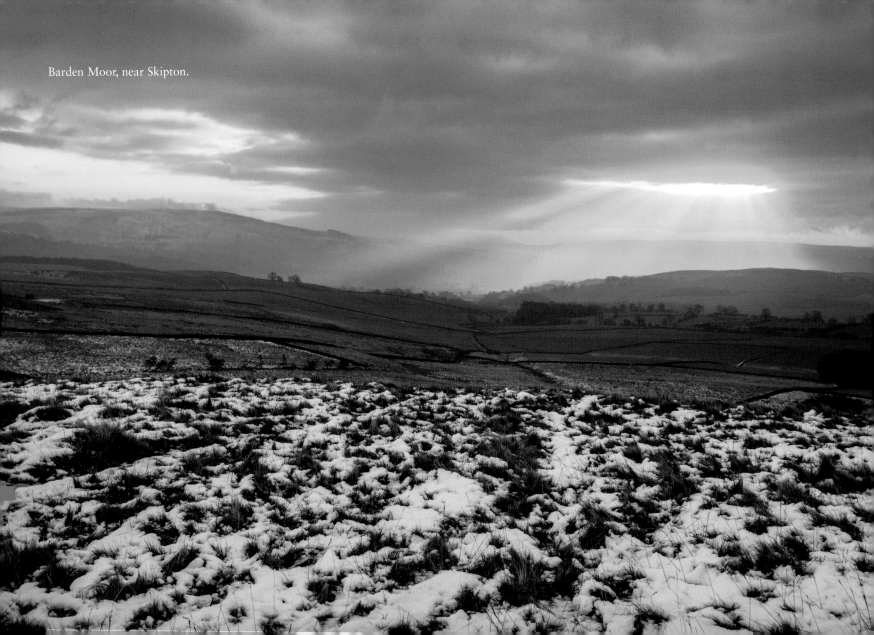

Barden Moor, near Skipton.

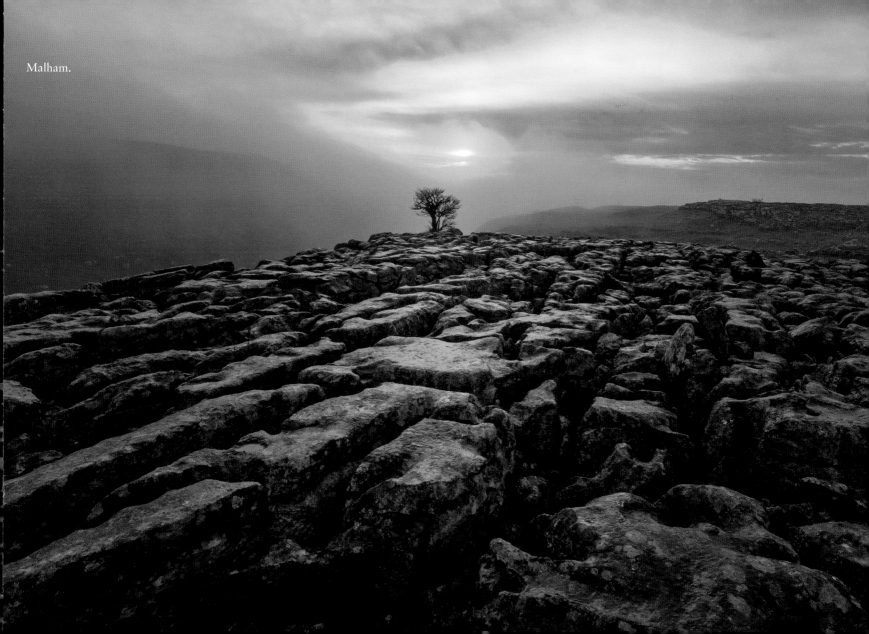

Malham.

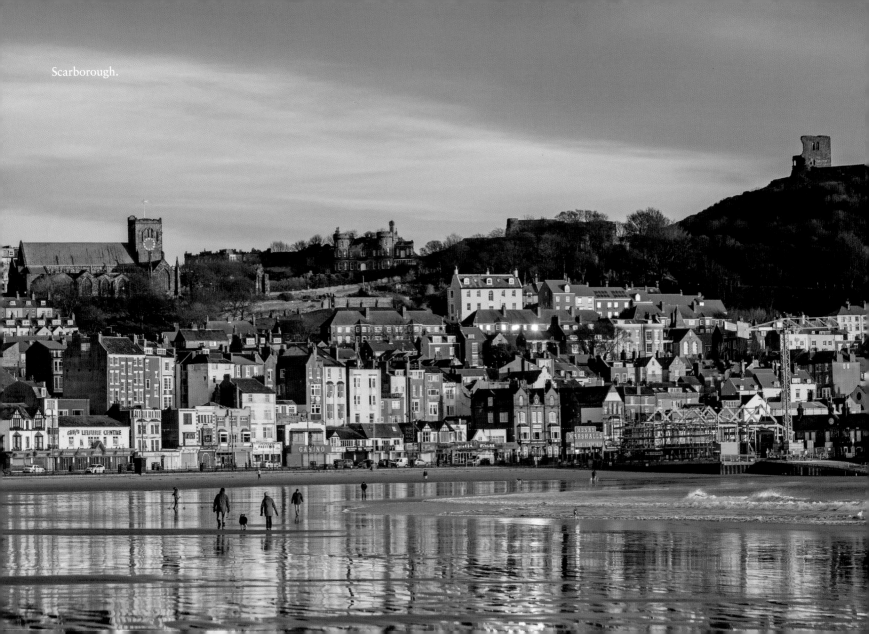

Scarborough.

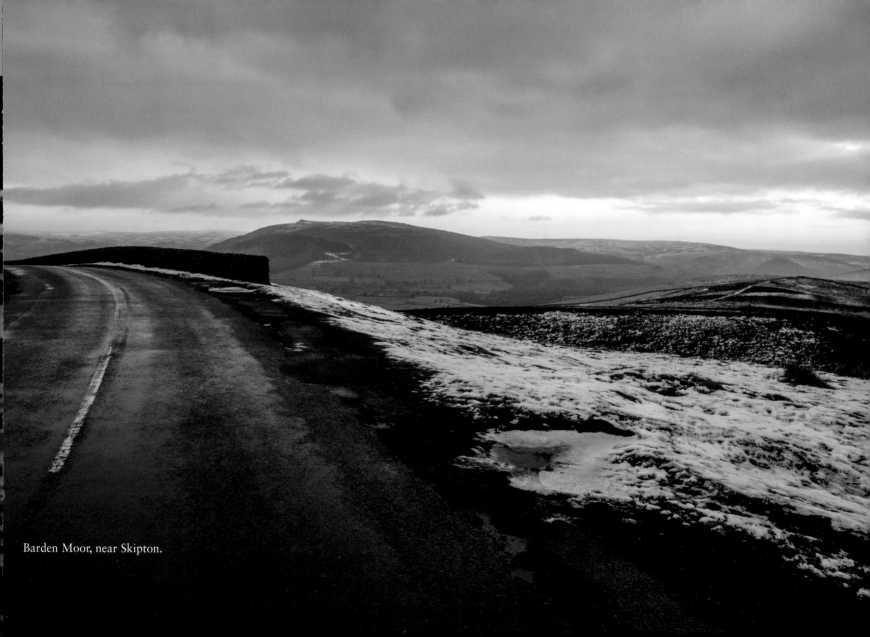

Barden Moor, near Skipton.

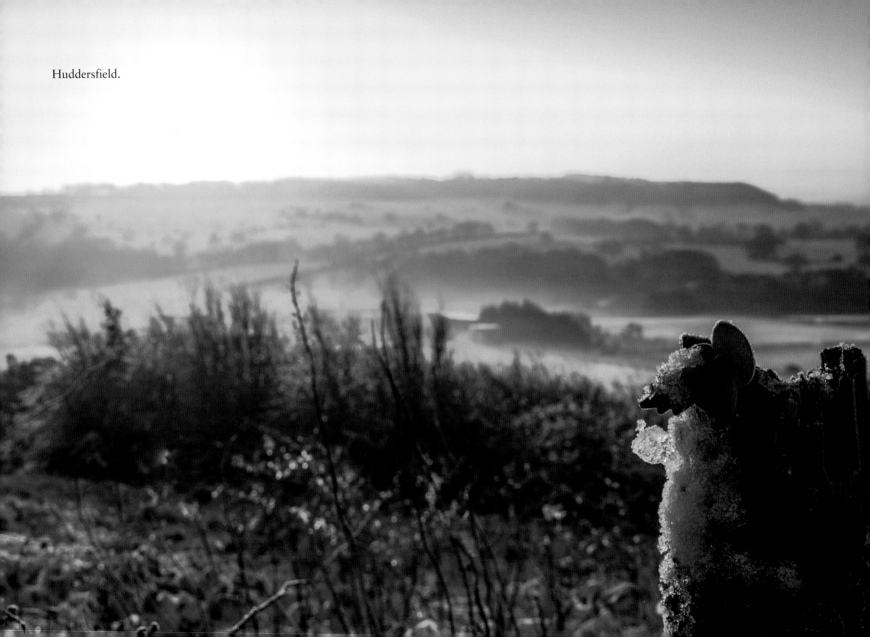

Huddersfield.

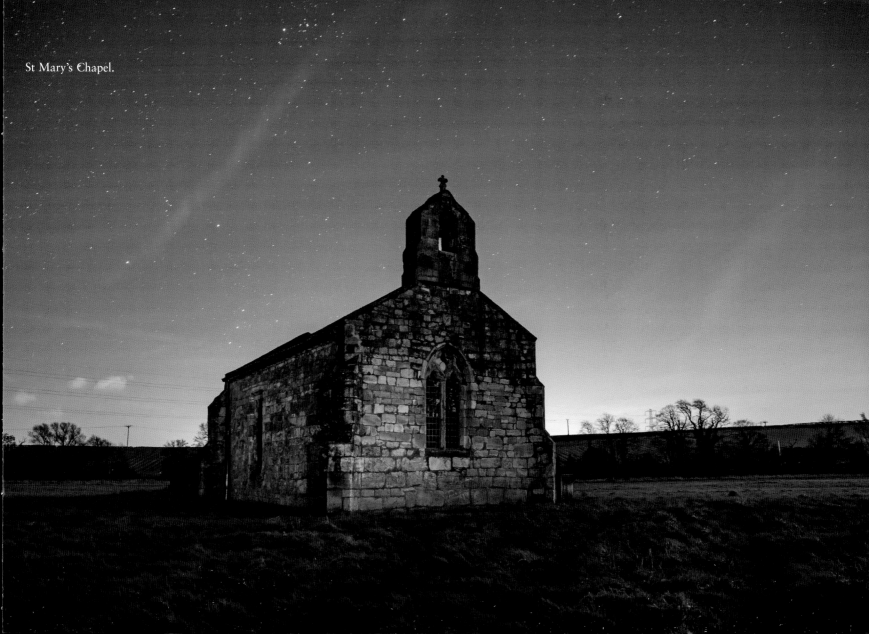

St Mary's Chapel.

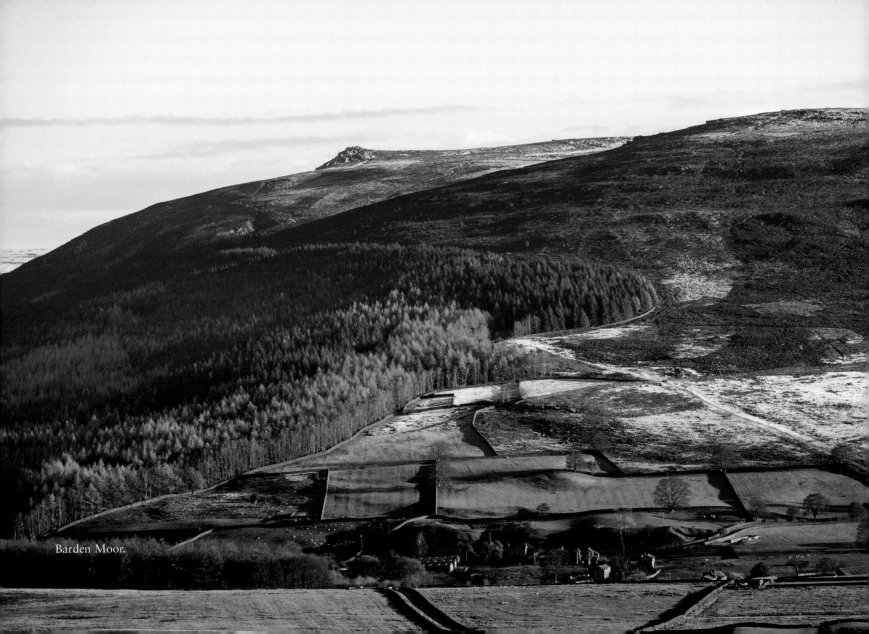

Barden Moor.

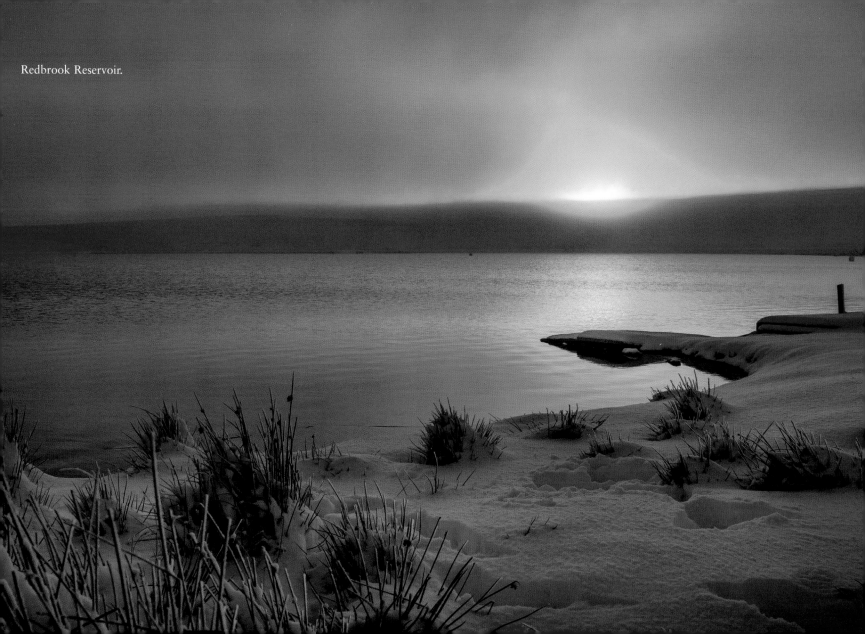

Redbrook Reservoir.

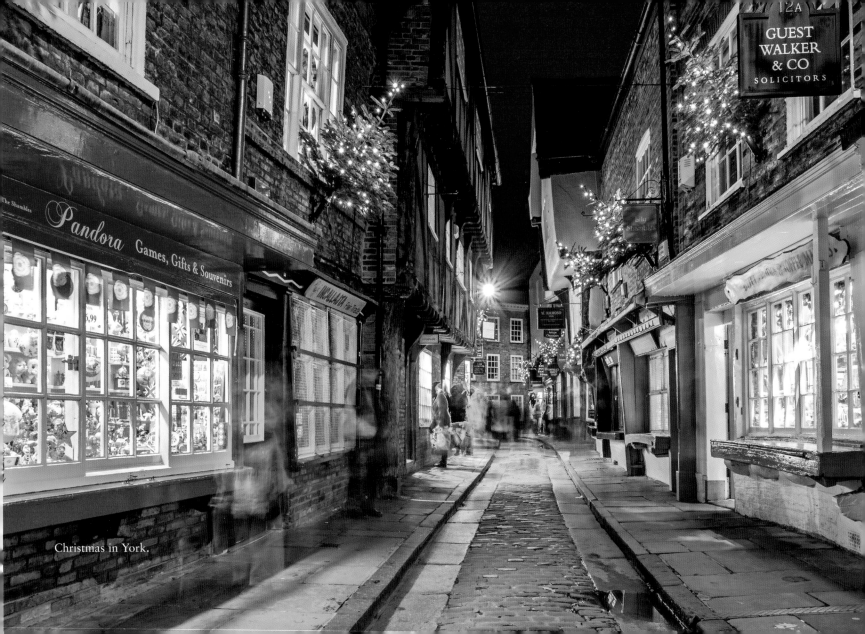

GUEST
WALKER
& CO
SOLICITORS

12A

Pandora Games, Gifts & Souvenirs

Christmas in York.